OAXACAN
WOODCARVING

OAXACAN WOODCARVING

THE MAGIC IN THE TREES

SHEPARD BARBASH

PHOTOGRAPHY BY VICKI RAGAN

CHRONICLE BOOKS

SAN FRANCISCO

P. 18: "Dog" and "Jaguar" appear courtesy of Paul and Augusta Petroff.
P. 99: "Alebrige" appears courtesy of Ron and Pipa Seichrist.

Printed in Singapore.

Library of Congress Cataloging-in-Publication Data:
Barbash, Shepard, 1957–
 Oaxacan woodcarving : the magic in the trees / Shepard Barbash ;
 photographs by Vicki Ragan.
 p. cm.
 ISBN 0-8118-0250-7 Pb
 ISBN 0-8118-0316-3 Hc
 I. Woodcarving—Mexico—Oaxaca—Themes, motives. 2. Folk art—
 Mexico—Oaxaca—Themes, motives. I. Ragan, Vicki, 1951–
 II. Title.
 NK9714.029B37 1993
 730.'972'74—dc20 92-37409
 CIP

Editing: Virginia Rich
Book and cover design: Karen Pike Graphic Design
Composition: TBH Typecast, Inc.
Cover photograph: Vicki Ragan

Distributed in Canada by
Raincoast Books
8680 Cambie Street
Vancouver, B.C. V6P 6M9

10 9 8 7 6 5 4

Chronicle Books
85 Second Street
San Francisco, California 94105

Web Site: www.chronbooks.com

FOR OUR SON, EDWIN

INTRODUCTION

The story of the wood-carvers of Oaxaca is an aberration: a rainy day in the dry season, a mile-wide storm in the desert of southern Mexico.

Imagine a country town outside a Sunbelt city. It is stable, closed, and poor. Suddenly, it finds an old treasure and grows rich. Imagine whole tracts of shabby housing bulldozed to the ground and replaced with stone mansions. Farmers buy more land. Their children stay in school. Town Hall is enlarged. The old church is restored. Strangers pour in and are welcomed. Imagine all of this happening incomprehensibly fast, within a few years, at a time when the rest of the country is sinking into the worst depression in memory. Finally, imagine these events being driven not by anything so inanimate as a treasure or a mineral in the ground but by the peculiar wizardry of the townspeople themselves and the whims of a distant neighbor.

There are two hundred or so families of wood-carvers in the Oaxaca valley, and this is very like what has happened to them. A wink of interest from that fidgety colossus, the American consumer, has broken their isolation, exploded their craft, and made over their villages. Cutting the chain to a thousand years of wretchedness, the carvers have soared from oblivion into the guidebooks on the wings of a fad. Egged on by tourists and salesmen, they have swept across the folk art world with a great mutating armada of strange and enchanting figures.

Ninety percent of the carvers come from one of three tiny villages outside the city of Oaxaca. Most are subsistence farmers who carve when there is nothing pressing to be done in the fields. Even in success, they would seem backward and poor by U.S. standards. Few have plumbing; most believe in witches. Moreover, their customs remain largely intact. The high point and unifying force in village life is the religious fiesta, as it has been for centuries. The staple crops are still corn and beans, as they have been for millennia. And though these pillars, too, seem destined to crumble—farming is a dying option, population pressures are growing, more young men commute to jobs in Oaxaca, immigration continues like a leaky faucet—still, the carvers are sanguine. They have had a patch of good luck, but God, like the American, is fickle, and they seem to know it can't last. Nothing lasts. The past is finally dead, great fortunes have been made, their world has opened wide, and still, the carvers wait for the other shoe to drop. Beset by changes, they have barely changed at all.

◆

Epifanio Fuentes was a wetback. Five times he tried to sneak into California, and five times he was tossed in jail by the border patrol. At one point he broke down and cried. On the sixth try he made

it to Corona, near Los Angeles, for the orange harvest and worked for half the minimum wage, much as his father had done before him. It was 1980. "There were people who hated us," Epifanio, a proud, intelligent man, recalls. "It was best to be invisible, do your work, and go home."

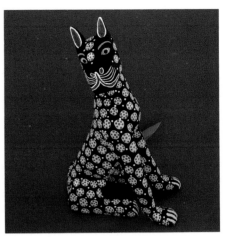

Since then, Fuentes has become one of the most celebrated carvers in Oaxaca. No one's angels are more beautiful. Father of seven, he is part of an extended family of ten carvers, including his father, a brother, three cousins, and two sons. In March of 1990, he and his wife, Laurencia, who paints his figures, were invited as distinguished visiting artists for a week to the Heard Museum in Phoenix, Arizona—orange grove country. They were then flown, permanent visas in hand, to Santa Fe, New Mexico, for another week by a store owner there, Ralph Farrar.

This time Epifanio was anything but invisible. In fact, Farrar says, after being announced at the museum's gala dinner, "he threw his arms up in the air like a prizefighter who had just won the heavyweight championship and strutted around the stage like a cock." Mexican-American relations had changed. The crowd applauded.

Carving in Oaxaca is not a bashful art. Full of gesture, painted in daring colors, it is as sudden and unrestrained as Epifanio's success, as shifting as his fortune, as magical for us as his plane flight above the clouds was for him. It is art made for export, a business opportunity seized upon by the mass of itinerants, underpaid masons, migrant tomato pickers, part-time butchers, bakers, handymen, corn grinders, street vendors, wood gatherers, and shepherds who populate the villages of the Oaxaca valley. It is both an escape from one of the poorest states in Mexico and an affirmation of its riches.

Oaxaca (pronounced Wa-HAH-ka) in the Zapotec dialect means "land of the *guaje*," a big, broad tree with ruddy red pods and bright orange flowers. Although smaller than West Virginia, the state is vast and varied. Home to sixteen linguistically distinct indigenous groups, it has produced Mexico's most revered president, Benito Juárez, an Indian, and its greatest tyrant, Porfirio Díaz. A two-hundred-mile trip from the capital, in the center of the state, to Puerto Escondido on the Pacific coast, begins in semi-arid valley, climbs foothills of cactus, winds for hours across the young mountains of the Sierra Madre del Sur, and descends several thousand feet into the tropics. It is a two-lane road. Along the way, hidden off either side are hundreds of settlements, an immense archipelago where people make do

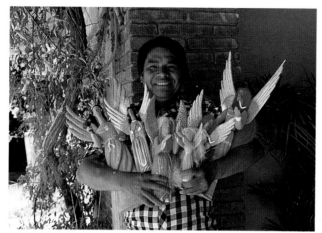

as they can: by throwing pots or weaving blankets or logging trees or exporting bananas or smuggling cocaine or warring over land or migrating to other states or simply by growing enough food to keep from starving.

Settled just a few miles apart, the three carving villages—Arrazola, La Unión Tejalapan, and San Martín Tilcajete—have more contact with their buyers in Texas than they do with each other. They have more words in common with the slum dwellers of Peru than with their neighbors a few hillsides away. One day not long ago, as carvers in San Martín were welcoming a fresh wave of tourists into their homes, a group of men twenty miles east in San Baltazar Chichicapan crouched low behind a wall of women and children, took aim with Uzi submachine guns, and wiped out an advancing detachment of soldiers who had taken two villagers hostage in retaliation for a drug-related murder. Tucked in the mountains beyond the central valley, shaded by a cover of trees, San Baltazar sends its pot to the United States and its wood to the artisans of San Martín.

In Oaxaca, history lives everywhere. The great Zapotec ruins of Monte Albán not only survive above the capital but grow, glacially, as pyramids are unburied bit by bit over decades. Archaeological surveys continue to piece together ancient settlements throughout the state. One carver dug up a pre-Hispanic funerary urn in his backyard and now uses the hole as a barbecue pit. Hundreds of old Catholic churches stand as reminders that the Spanish came, conquered, and, even after Mexico's independence, stayed on.

Sunk deep into the eyes of rich and poor alike one sees the dead weight of the past as well: the millennium of serfdom, feuding, and ritualized butchery under Indian kings, followed by centuries of forced labor, land grabbing, and imported pestilence under the Spanish crown. It is safe to assume that the Zapotec ancestors of more than a few people carving today had their tongues cut out, their ears bled, their bodies consumed, and their hearts served up whole to gods of low-fired clay. Five hundred years ago, not far from what is now La Unión, wives suspected of philandering were roasted and fed to their friends. Later, under the Spaniards, families scattered about the hills of San Martín were yanked from their homes and packed together close by in the valley; men were pulled from their fields to mine stones and silver or carted off to till distant lands of imperial strongmen. Well into this century,

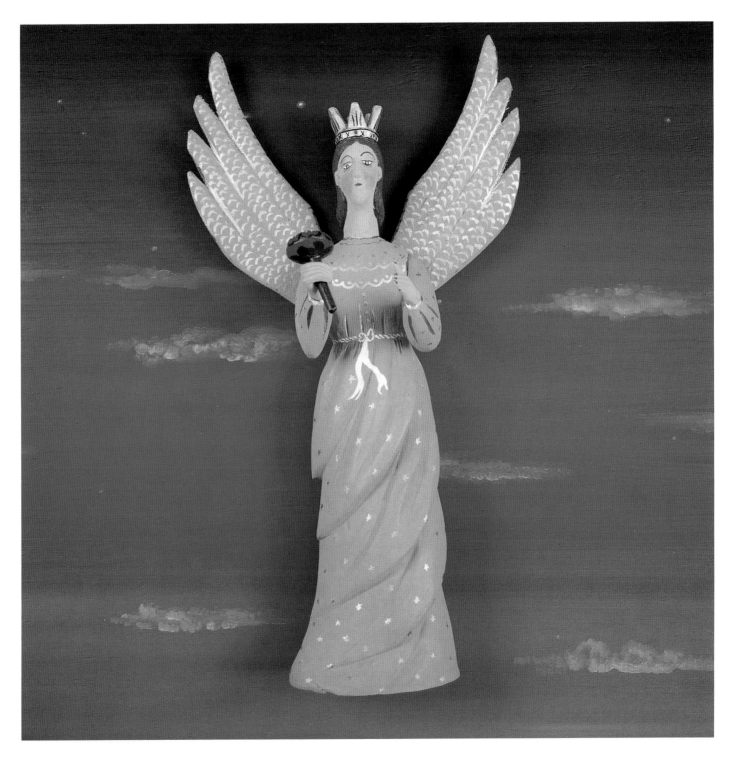

facing page:

Epifanio Fuentes

above:

Angel

Epifanio Fuentes

following page:

Manuel Jiménez with

wife, **Viviana**

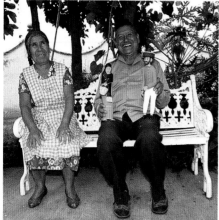

the village of Arrazola was no village at all but a fragment of one man's vast sugar hacienda, on which men, women, and children worked from dawn to dusk as peons.

Sprouting inexplicably from this misery is the great flower of popular art. Stretching out from the capital, the Oaxaca valley nurtures an astonishing diversity of crafts. There is black pottery, red pottery, green-glaze pottery, fireworks, ornamental tin, and jewelry. There are serapes, belts, blouses, baskets, combs, candles, and puppets. For the Night of the Radishes in December, Oaxacans carve elaborate scenes out of radishes. For funerals, they paint with sand. Indeed, it is a testament to the region's inexhaustible reserve of creativity that wood carving—one of the best-selling Mexican crafts in the United States—is just one more star in the valley's dense, swirling galaxy of artistic traditions.

Heir to this treasure, why shouldn't Epifanio strut? The carvers' range of expression is enormous, their subject matter limitless, their technique often masterful. They carve cactus and kings, devils and ox carts, Virgins and skeletons. They make hundreds of different animals. They carve earrings, tie tacks, bracelets, picture frames, and chairs. They capture the immediate world of village life and the universal world of dreams. Naked bird-headed women mingle with monsters, psychedelic cats, and San Isidro, patron saint of the peasantry. Fierce purple lions tower over dancing chickens. Our friends from Mexico City insist the carvers eat hallucinogenic mushrooms. They don't—they just have active inner lives and a fearless palette.

Most of the people now carving began after 1985. Lacking the constraints and wisdom of a long artistic tradition, they rummage freely through the region's immense creative heritage, its jumbled culture of Indian and Spanish, Catholic and commercial, tourist and local. Motifs change monthly, driven by the competition, the market's emphasis on novelty, and the carvers' own restlessness. Quality varies wildly, both among artisans and in the day-to-day work of individuals, and the magic is often serendipitous. Artisans—they almost never refer to themselves as artists—are the first to admit that they don't always know what they're doing or why a piece is deemed good. If it sells, they say, it's good. If it's *big* and it sells, then it's *very* good. (Clients pay by the centimeter.)

In defense of the salesman, who is often accused of killing the goose but without whom no carving renaissance would have been possible, buying and selling Third World folk art is no easy business.

Competition among dealers is intense, supply is erratic, and shipping costs from pueblo to gallery are high. Retailers in the United States must generally charge four to five times what the carvers are paid just to stay in the black. Their market is also confused. Carvings have sold at fancy galleries for thousands of dollars and at Macy's and Bullock's for a lot less. They have been direct-mailed out of the Pottery Barn catalog and sawed in half and sold as napkin holders at gift shows. They have served as window dressing in clothing stores and design statements in *Architectural Digest.* They can be found in museum collections and tacky border town markets.

In Oaxaca, collecting for us has been a roving scavenger hunt. Variety reigns, which means that good pieces turn up everywhere, but often only once. We have bought figures from hotels, drugstores, outdoor bazaars, even restaurants. We own carvings from seventy different carvers. When asked, we offer this advice to our friends: if you see something you like, buy it, because you'll probably never see anything just like it again.

◆

Oaxacans have carved toys for children and masks for religious fiestas for hundreds, perhaps thousands of years. The style that dominates today, however, can be traced back to a single man, seventy-three-year-old Manuel Jiménez from Arrazola.

It was Jiménez who discovered the wood that all the carvers now use, *copalillo,* after experimenting with a dozen different trees. It was Jiménez who moved far beyond the popular tradition of miniature toy making and gave the carvings their larger scale, finer execution, and more ambitious subject matter. And it was Don Manuel, as many now call him, who through his commercial success established the international market for all the carvers who came in the decades after him.

It wasn't easy. For thirty-five years, Jiménez was among the poorest peasants in a very poor village.

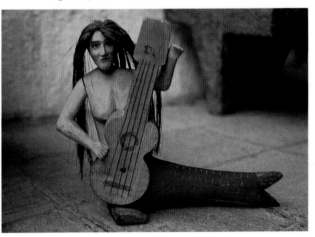

Settled tightly at the base of Monte Albán, Arrazola is a former plantation only now recovering from a century of serfdom. Jiménez herded goats as a boy, making models of his flock in clay. As a young man he would go barefoot into the hills, clothed in tatters, to forage weeds and grasshoppers.

For twenty years he moved from one job to another—cane cutter, mason, band leader,

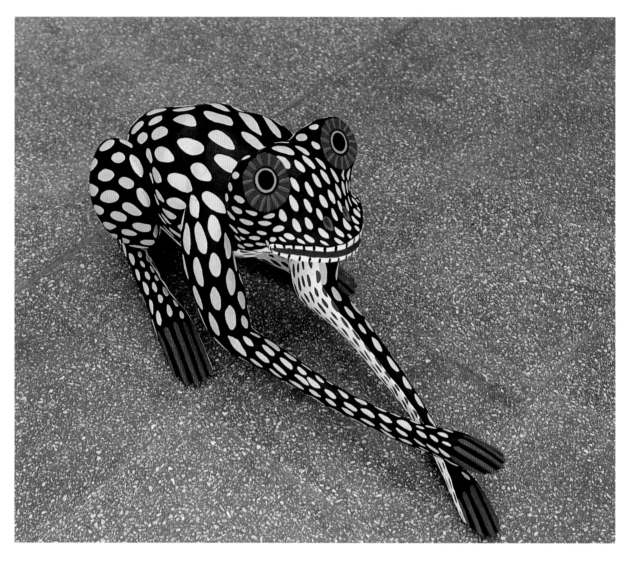

previous page:

Mermaid with

horsehair

Manuel Jiménez

above:

Frog

Manuel Jiménez

facing page:

Old couple

Manuel Jiménez

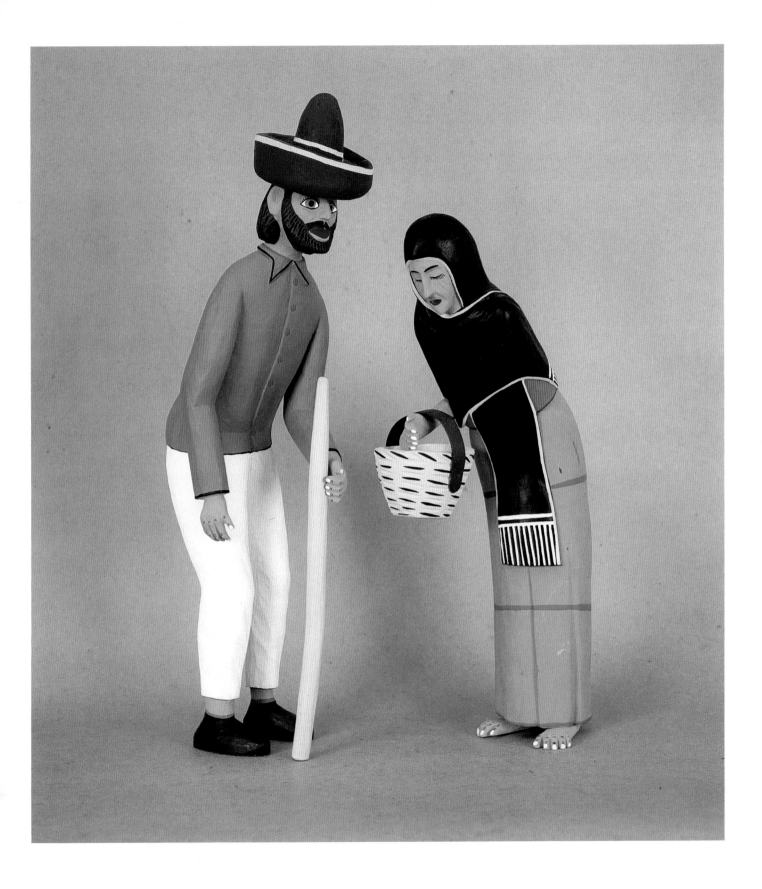

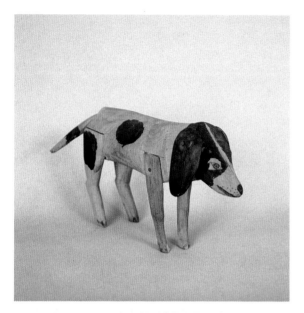

left:

Dog

Manuel Jiménez

lower left:

Jaguar

Manuel Jiménez

below:

Nahual with ixtle
beard

Manuel Jiménez

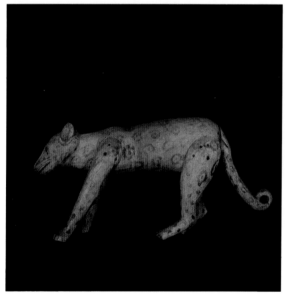

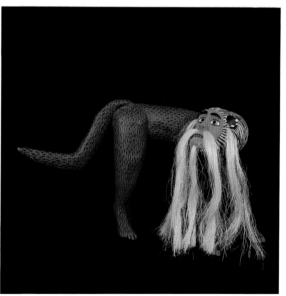

barber. He opened a store. He carved masks to sell at Monte Albán. Finally, in 1957, he was discovered by an American living in Oaxaca, Arthur Train, who launched his career.

"I've never seen another like him," Train, who has since retired, says now. "The individuality of Manuel is enormous. You say 'Three Kings' and he can visualize them, and in his own way. In all the years I was here, I ran into very few people whose work really expressed something of themselves as individuals. For Manuel, that was always true. Give the Devil his due."

Jiménez is every bit the difficult artist. He is by his own account one of the great geniuses the world has ever seen. He commands prices four times those of his closest competitors. A reformed alcoholic, he lives behind a wall topped with shards of glass in an immense concrete house that overwhelms the adobe huts and dirt patios of his neighbors. He is a self-proclaimed faith healer and prophet and is convinced the world will end with the end of the century.

"No one endured what I endured," Manuel often says. "I suffered, but I robbed my destiny." Deprived of school, he taught himself how to read. Deprived of land by his father, who beat him as a boy, he became the largest landowner in Arrazola. Addicted for years to alcohol—two of his brothers already dead from it, his own liver and kidneys irreparably damaged—he stopped drinking entirely.

"Mine is a sacred history," he says. "I am not just anybody, I am a real tiger. I was born intelligent. Everyone here is living off my initiative. If I hadn't started carving, no one would be doing anything. I invented the whole tradition. They should make a statue for me in the plaza, with an arrow pointing to the house, and rename this street Jiménez Street. For Jiménez will never die. I am like the sun in the sky. Oaxaca without Jiménez would not be Oaxaca."

In a sense, he's right. Even Manuel is shocked, horrified, when told that there are now hundreds of carvers and dozens of shops in Oaxaca that carry their work. Most of the artisans have built new houses, replacing adobe or bamboo with brick. Many have bought farmland. The most successful own cars. Virtually all entertain tourists regularly in their homes. (A few will accept checks.) Several have studied English with an American, who for a time came right into the dirt yards of their Zapotec-speaking grandparents to teach among the cows and chickens.

It is hard to imagine more sweeping prosperity descending upon a society in less time. In La Unión, middle-aged fathers remember waking hours before dawn to gather dead branches, for a few pesos a burro-load, to fire the kilns of the neighboring pottery village of Atzompa. Their sons now earn ten times that amount carving fresh-cut copal for a collector's market more than a thousand miles away. Most carvers born before 1950 grew up poorly fed, sheltered in leaky huts and illiterate; many

had no land and worked as peons for local bosses, or as field hands in Texas, or as itinerants scattered in the wind. Now, the men stay home, and the children study. People don't go out into the hills hunting for grasshoppers anymore, one old-timer says, summing up his view of how things have changed. No one is idle in a successful carver's family: father and sons carve; mother and daughters paint; smaller children and elders sand. Working this way, a good carver can earn as much as an elementary school teacher and much more than a mason.

Though Jiménez deserves credit as a pioneer, the great irony of the carving boom is that it was in fact made possible by the country's economic disintegration. In 1982, following a decade of state profligacy, world petroleum prices dropped, and Mexico's oil-based economy collapsed. Fighting bankruptcy, the government was forced to devalue the peso against the dollar and pursue a policy of growth through exports. Though the devaluations sent inflation soaring and devastated purchasing power inside the country, it also made Mexican products, crafts among them, a terrific bargain abroad. What's more, while Mexico limped along, the U.S. economy grew, sucking in imports. To the legion of U.S.-based folk art dealers combing the world for products, Oaxaca became a natural: Mexican culture was hot, folk art was in, and the carvings in particular fit nicely with the popular Southwest look in home design.

Although few of them realize it, the wood-carvers are doing exactly what the Mexican government has been urging the country's business elite to do for nearly a decade, which is to hitch their wagons to the world economy. Instead of working for other Mexicans at depressed peso wages, or not working at all, the carvers are in effect working on favorable terms for Americans, generating wealth through exports, working efficiently and competitively, doing the patriotic thing by bringing much-needed dollars into the country and social peace to the countryside.

◆

Our little boy loves our collection of carvings. "Mommy's toys," he calls them. They make good playmates, eager to swap stories or go off on adventures. Like sugar scenes in an Easter egg, they are loaded with the kind of crudely executed but painstaking detail that children love. They wear obvious expressions. But like all magic, the carvings deceive. Back home from the villages, surrounded by our cheery menagerie, charmed by our son's untrackable journeys, we forget their bittersweet origins.

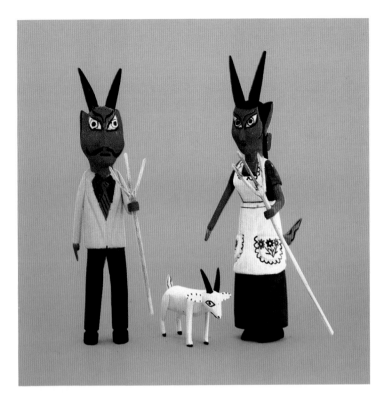

facing page:

Jaime Santiago

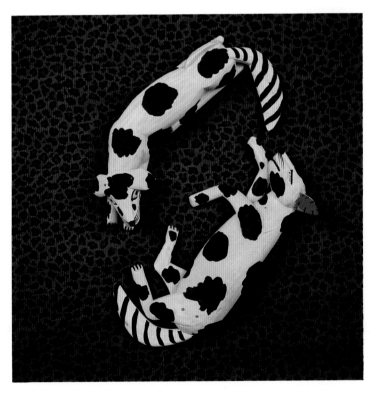

above:

Devil pair with goat

Jaime Santiago

left:

Dogs

Jaime Santiago

Routine life in rural Oaxaca is dominated by the most elementary, physically demanding chores of survival. This is true even in places lucky enough to maintain a thriving crafts industry. As of January 1992, the three carving villages had a combined population of less than five thousand, a median annual family income of less than $2,500, no paved roads, no stoplight or road sign of any sort, no movie theater, no restaurant, no high school, no resident doctors or lawyers, no garbage collection or sewage system, no running water, one ball field, two telephones, a tiny agricultural surplus, and more farm animals than people.

By far the poorest, prettiest, and most remote of the three villages is the collection of mud houses known optimistically as La Unión. Flung improbably across a series of bare hills, La Unión gets no tourists and only a few intrepid salesmen. Carvers must take their wares into Oaxaca, a one-hour bus trip that entails twice fording a wide, shallow river. Forced to work a stingy soil in a fickle desert climate, few villagers grow enough even to feed themselves. Land holdings are tiny and treasured, like pearls, because jobs away from the farm are scarce. Migration to Mexico City is high. There is only one full-time carver, Jaime Santiago; the rest tend daily to scattered half-acre patches of corn, beans, squash, and alfalfa. Fields are plowed with bulls.

Santiago, one of the most talented, versatile carvers in Oaxaca, lives on a hillside overlooking the village, within view of its tele-secondary school, its one-room health clinic, and its nonfunctioning water tank. Like his poorer neighbors, Jaime has no plumbing and must carry water from a brackish stream up the steep incline to his house. His wife, Reina, spends several hours a day bent over a smoky wood fire cooking tortillas. Like most of the villagers, the couple and their three children relieve themselves in an open field near their house—a new cement house financed by the proceeds of carving.

Jaime works hard and efficiently—eight hours a day, six days a week, one hundred small figures a month, with few artistic blocks in between. Three times a week—"to keep me going"—he walks down to a cracking cement court by the health clinic and plays basketball, the only game in town. Like a lot of the better carvings, Jaime's pieces—buck-toothed rabbits, wild-eyed dogs, loud fiestas—soar above the tedium of village life even as they depict it. The endless struggles that fill a carver's days motivate but at last recede from his work.

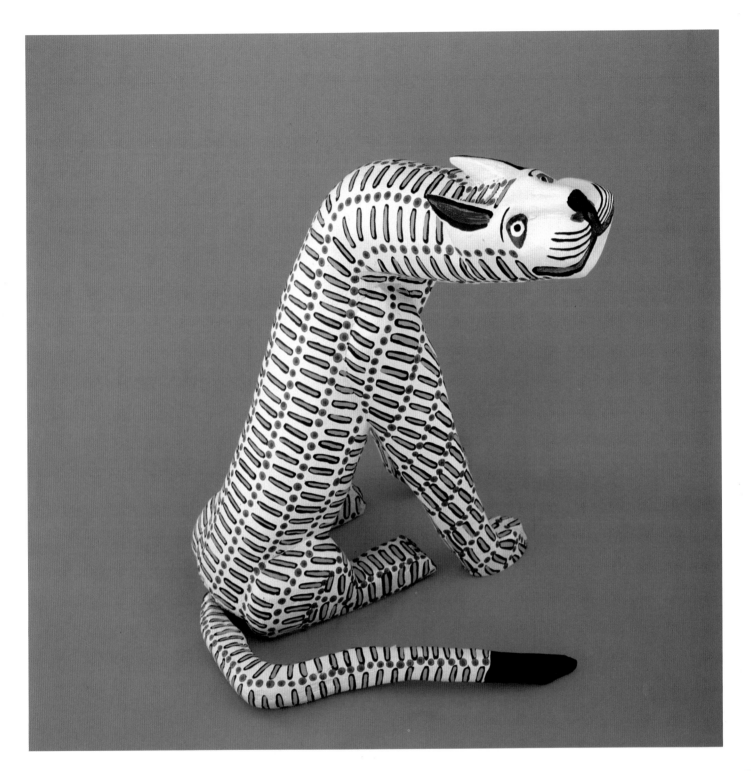

facing page:

Margarito Melchor

above:

Cat

Margarito Melchor

and **María Teresa**

In San Martín, Margarito Melchor carves cats—murderous tigers and playful kittens, lions devouring sheep and house cats batting balls, smiling jaguars drowsing in the sun. His wife, María Teresa, paints them in riots of color—polka-dot reds inside oblong yellows against solid cobalt blues. Melchor cats are at once true-to-life, fantastic, and mysterious, but to Margarito and Teresa they mean one ·thing: a lifeline.

Two of the family's three sons were born with juvenile nephritis, a hereditary kidney disease. The eldest, Beto, died of it in 1985—two years before the cats started bringing in the kind of money and advice a peasant needs to secure decent medical help. (In 1985, the Melchors relied on faith healers.) The youngest son, Arturo, was not expected to survive adolescence without a kidney transplant, and for the last four years his parents worked frantically to save enough money for the operation, without success. On October 14, 1992, at age fourteen, Arturo's kidneys failed. Unable to do anything for him, doctors in Oaxaca sent him home, where he died, lying face down, surrounded by candles and a crowd of praying villagers. After carving for twenty years—selling thousands of figures, hundreds of cats—Margarito must still borrow money against the sale of future carvings to pay the boy's medical bills. When children like my son play with a Melchor cat, they are playing with collateral.

The Melchors do not struggle alone. The oral histories of the carvers are filled with misery almost without exception. Violence, peonage, abandonment, death upon death of mothers, fathers, infants, and friends—the horrors of the past pour out in quiet reportage.

"I am my father's last child and my mother's first," Inocencio Vásquez says, as if reporting his birth weight. "I grew up with my uncle."

"My mom left when I was forty days old; I grew up on goat's milk—that's why I'm so strong," Antonio Xuana says with a laugh.

"When I was seven my father was killed outside his house," Eva Garcia says. "He was shot by his *compadre,* who thought he was a bandit. It was five in the morning. My mom had a baby that night and died two weeks later. The baby died soon after that. I moved in with my uncle, but he beat me so I ran away to another aunt."

Margarito, Teresa, Inocencio, Antonio, and Eva are not only successful artisans, they seem like good spouses and loving parents as well. Indeed, their equanimity about the past is breathtaking to behold: as if they were talking not of themselves but of people as dead and distant as the Aztec kings; as if they had emerged not slowly and imperceptibly from childhood but all at once, like their carvings, or like monarchs from a cocoon—transfigured and unbound, miraculously warm and functional. Such

decency! Where did they get it? From the women—the captive women who raised them? From the village, with its masses, fiestas, and communal harvest? From the sense of belonging and duty that these rites engender?

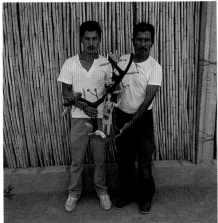

Perhaps it is no coincidence that all five artisans live in San Martín. Of the three carving villages, San Martín is the oldest and most tightly bound by tradition. Carvers here proudly note that their ancestors two thousand years ago paid tributes of corn and beans to build Monte Albán twenty miles away. Pottery sherds dating back to the sixth century B.C. have been found on the treeless hills outside town, on land now abandoned by all but the ghosts of local legend. An eighteenth-century church rises six stories into the clean desert sky, visible from nearly every home in the village and matched in grandeur by an immense jacaranda tree shading the dirt plaza with purple flowers.

This is a united, peaceful town. Ninety-five percent of San Martín's twenty-five hundred people are Catholic. The last murder was thirty years ago. The official, rigged vote tally from a recent statewide election was 317 votes for Mexico's ruling Partido Revolucionario Institucional, zero for the opposition. No one protested.

San Martín has always been an artisan's town. If my son were a girl and had been born a few years earlier, instead of playing with Margarito's cats she might have worn one of his aunt's embroidered shirts, which sold well during the 1970s. If I had been around in the 1940s, Epifanio's dad, Xenén, might have sold me one of his reed baskets, or, a few years before that, a bird cage made of bamboo. From his neighbors I might have picked up a trim votive candle. Before that, the village made shirts and blankets; before that, clay pots and mescal; before that . . . memories fade.

None of these crafts generated much wealth for the village. Nor did they have anything like the bone-jarring impact that carving has had on village life.

◆

"Movement! Movement! Movement!" Miguel Santiago's words rang off the cement walls of his alcove. Grabbing an unpainted chicken from the floor, the carver rapped a wing, drew a line across it with his hand and threw the bird back at his apprentice. "This cock is dead!" he declared. The old man, José, gave Miguel a blank look. Miguel glared back. At last, father and son went back to work.

The social world of the carving village is being turned upside down. Eternal chains of command

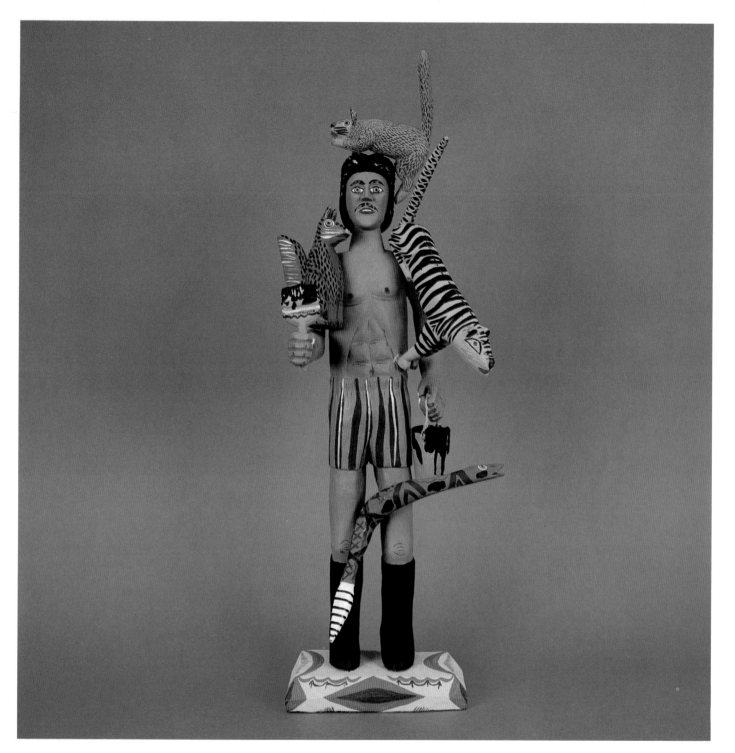

previous page:

Miguel Santiago

with father, **José**

above:

Portrait of artist

Isaiah Zagar

Miguel Santiago

have been broken. Power is floating backward. Gone are the days when children could expect to be beaten for failing to salute their elders with a cross-armed bow. Raised to obey, teenage carvers find themselves thrust into the awkward roles of breadwinner and *maestro*. Fathers find they have little to teach their sons, and less to give. Their inheritance lies elsewhere—in New York, San Antonio, Los Angeles, Santa Fe.

For years carving was frowned upon as a feminine pursuit, no different than pottery-making. Carvers were derisively called doll makers. Men were supposed to be out sweating in the fields, not sitting in the shade within earshot of their wives, catering to a gringo's whimsy.

Now, suddenly, carvers are the envy of all. Competition has strained friendships and families and intensified old fears. Woe to the son who lacks talent for carving. Woe to the parent who hasn't a son. Woe to the buyer who asks for directions: "Manuel Jiménez? Oh, he died. Epifanio Fuentes? He's moved away. Miguel Santiago? Sure, that's me. La Unión? Never heard of it. Would you like to see my brother's carvings?"

Afraid of being copied and undersold, carvers go to great lengths to hide their figures and to vary them. The result has been a kind of wandering curio arms race, with innovations driven more by fear than dialogue or aesthetics or anything else. Indeed, the carving boom is aesthetically rudderless; hence the welter of gaudy inventions, all screaming for attention. "We never exchange ideas, not even within the family," one carver from the large Santiago clan in La Unión says.

Mexicans value discretion, and there was no reason to expect that a sudden bonanza dropped in the laps of a long-marginalized people would make them any less suspicious; if anything, it has made them more so. On the other hand, the chance of a lifetime to earn good money has not spoiled their good nature. Moreover the civilizing laws of rural society still apply: no carver would dare refuse food or precious water to anyone, not even his most hated rival. *Tequío,* the ancient system of required service on village work projects, is still dutifully honored—even if a carver has to pay somebody to take his turn while he's out of the country.

Few visitors to the artisan towns of Oaxaca are not struck by the immediate graciousness of their hosts, their eagerness to please, their unstinting, reflexive generosity. Forced by necessity to share with each other, they are only too glad to do likewise with foreigners, whom they tend to see not only as their meal tickets but as their betters.

Bringing my own lunch into the village was a serious offense. Carvers competed for the high honor of stuffing me with more beans and tortillas and broths and eggs than they themselves would

ever eat. (This in turn led me to contract the usual maladies one contracts when dining for extended periods in rural Mexico: amoebic parasites and hepatitis.)

The hospitality could reach comic extremes. Once, needing a place to stay in San Martín, I imposed reluctantly upon Eva Garcia and her husband, Coindo. The family, better off than most, had a double bed, two twins, a cot, and several grass mats. Even so, with eight people living in two rooms, I knew that my presence would force somebody else onto the ground, as they would never let me sleep on a mat.

In fact, it was to be worse than that. When I arrived, the entire clan, with whom I had become quite familiar, had cleared out of the room with the double bed. They insisted I sleep there—alone, with the empty cot at my side—while they, six adults and two children, squeezed into the remaining twin beds and onto the cement floor. For two weeks. In the dead of winter. Whether they felt bound by notions of honor and modesty or by peculiar ideas of how Americans live back home, nothing would dissuade them. "This is your house," Mexicans like to say.

The flip side to this unrelenting generosity is bald profligacy with another's resources. Few peasants steal—most carvers would return a lost purse unopened. The preferred method for redistribution of wealth in the villages is a kind of ceremonious, institutionalized begging, in which the solicitor requests a specific gift and offers the donor a meal or two and the respectful title of *padrino* in return.

Foreigners make great patrons. To a carver, their wealth is unfathomable, like mountains of corn in the village shed, incalculable except by volume. He cannot see how you could possibly miss the thousand dollars he desperately needs you to lend him and acts hurt or puzzled if you refuse. Weren't you his friend? How can you say no? And so, you help one friend buy a lot to build his house. You help his father pay off a usurer. You help another friend pay his child's medical bills. You become patrons for a carver's wedding garb (he goes out and buys the most expensive tuxedo in Oaxaca), a little girl's graduation dress (she has just finished kindergarten), several cases of beer, and half a dozen birthday cakes. As I write, someone we have not heard from in two years has phoned us in Atlanta to ask that we sponsor the rock band for his daughter's coming out party—six hundred dollars' worth of music for a sixteen-year-old who lives with no plumbing.

"The Devil laughs at he who lends," Manuel Jiménez, no slouch as a moneylender, once warned me. "The Indians close their eyes and come charging on top of you, like shameless horses. They will eat you alive if you let them." Ready to share what he has, the peasant is not afraid to ask for what he doesn't. Unless he is a saint or a fool, foreigners seem to him like floating timber to a shipwrecked crew.

His offense is not one of dishonesty or greed but of naiveté and survival, and it suggests just how enormous is the breach between Oaxaca and the world of its star-struck visitors. Having left their poorer neighbors behind, the carving villages still remain fifty years and a million dollars away from their patrons, in a messy space all their own.

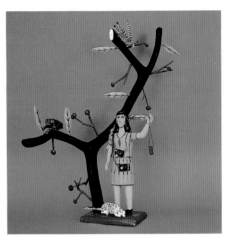

◆

Three narrow outhouses stand side by side like little silos on the dirt hillside next to La Unión's tele-secondary school—separate pits for boys, girls, and *maestros*. Squatting in any one of them, a young rogue with a decent arm could toss a rock up to the school's corrugated roof and knock out its satellite dish.

Like many villages in remote regions of Mexico, La Unión gets its state-sponsored junior high school curriculum in discrete seventeen-minute packets beamed from Mexico City. Two teachers are on hand in the classroom to help shepherd the pupils through taped lessons in science, history, and geography. Homework arrives via television, is copied diligently into weathered notebooks, and is carried home each afternoon on foot—past cows and burros, across trickling streams, up over ridges, around vicious dogs, and into dust-covered shacks, where the work is done, or not done, on dirt floors lit by bare bulbs.

Instruction by satellite at noon, meals in a hut two hours later—life with the carvers is an accretion of time lines. Spasmodic intrusions of technology are but one aspect of the wild agglomeration of notions, symbols, practices, and TV programs that make up village culture. Indeed, so many odd remnants have been stitched together that they come to feel almost natural, so that village life today has become a homey jumble of indigenous traditions and cast-off Americana, earthenware pots and polyester shirts, Cokes in green bottles and gourds of mescal, battered Fusbol tables and machete-hewn tops, electric guitars and goat-skinned drums, cesarean sections and bear-paw elixirs, pinup girls next to holograms of Christ. Old and new clash right off the plane. On the road to Oaxaca from the airport, facing the ancient pyramids of Monte Albán is a billboard for a restaurant that reads:

"Garlic and Onions"

Tradition since 1975

Ten years younger than Garlic and Onions, the carving boom remains unknown to most Oaxacans, even to some in the villages it has transformed. Like characters in a science fiction story, neighbors

manage to live side by side but in different ages. In San Martín, where dozens of families entertain Americans every day and young men return each Christmas from their jobs in California, I have had young girls bolt from the dinner table upon discovering who I was. Gringos, they had been warned, no doubt sincerely, kidnap little children and spirit them off to the States.

Levels of sophistication vary enormously even within a single-carving family. On one memorable occasion, Margarito Melchor and María Teresa made a special trip into Oaxaca to return a camera we had forgotten. Waiting for me to get off the phone and log off my computer, they took a seat before the VCR and watched in mesmerized silence a tape of "Peewee's Playhouse." As the protagonist shot off into the credits on his bicycle, Margarito conferred for a moment with his wife, then asked, "Does everyone in America have talking chairs?" Epifanio, his brother-in-law, had twice gone to the States but had never mentioned them. Did only rich people have them?

The innocence of the question, the readiness to believe anything about America, no matter how absurd, is in fact wholly consistent with how the carvers have handled the more bizarre aspects of their own "modernization." No hand-me-down scrap of U.S. culture is too bogus, no client's order too strange to be absorbed. Talking chairs and bicycle jets? The carvers have accepted stranger things.

On a cold night in January, Coindo Melchor sits in his bedroom carving naked bird-headed goddesses from a picture book and watching Spanish-dubbed reruns of "My Mother the Car." But he listens, too, for the fireworks in the village square, the signal to all that it is time to stop work, that the Three Kings have arrived on their horses, as they have each year for as long as anyone can remember. This, then, is modern village life: a bit of pop mythology, an imported drama about a car that talks, and a beloved local pageant—all in one evening. To Coindo, there is nothing surreal about the combination, just as there is nothing surreal about his winged women.

"The peasants are adults, and they know how to choose," a Mexican who has studied folk art booms said reassuringly after hearing me fret about the future. But the choices are hard. Coindo's son, Inocente, known to all as Juan, was among the finest carvers in Oaxaca. Dealers competed for his work. But Juan was young and wasn't always interested. He would watch the TV shows, cheer the 49ers, listen to Madonna, practice martial arts, ogle the imported gadgetry. He lost a few friends to California. He watched his grandmother die in the adobe house of his uncle next door—blind, unmedicated, spitting up blood, moaning in Zapotec, a language he had never learned.

In May of 1991, Juan and his family landed in *Smithsonian* magazine, which ran a story on the carvers and a full-page photo of the Melchors working by candlelight. Juan knew the issue was coming

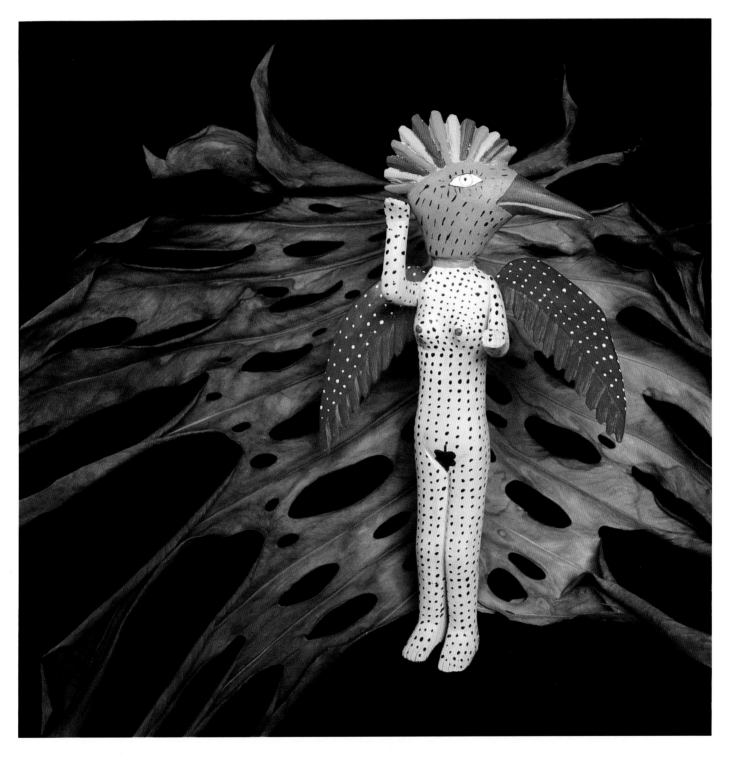

Page 29:

Portrait of Vicki Ragan

Miguel Santiago

above:

Bird-headed woman

Coindo Melchor

out, but he didn't wait. He sneaked across the border and got his copy in Albany, New York, where he has lived for more than a year, washing dishes fifteen hours a day. *"Compré un 'Moos-dang.'* I bought a Mustang," he says. He also has a telephone, and talks regularly with his friends in California, several of whom had been carvers back home.

So strong is America's grip on the imagination that it overpowers even the most accomplished members of village society, pulling them irresistibly northward. That Manuel Jiménez did not heed this siren call explains in part his renown as a carver. While others of perhaps equal talent came and went, he stayed home for thirty-five years and carved.

Celestino Cruz of San Martín, for instance, outdid Manuel to take first prize in several government-sponsored carving competitions during the 1970s. To this day, there are experts who say Cruz was the more gifted carver. Why, then, was it Jiménez and not Cruz who became famous? It is like asking why Pete Rose is more famous than Pete Reiser. Reiser, the brilliant center fielder for the Brooklyn Dodgers, chased a fly ball into the brick wall at Ebbets Field and destroyed his career after a handful of seasons. Cruz, after a few good years' carving, chased his fortune to Santa Cruz, California, where he toils to this day as a packing clerk.

◆

Inocencio Vásquez, the talented young carver from San Martín, felt a knot tighten in his stomach as Don Ramón entered his hut and, even before being fetched a chair, placed his order.

Here was trouble. The teenaged artisan, a soft-spoken but devout member of the village church commission, was politely being asked—in the name of art and commerce—to blaspheme the Holy Trinity.

"Enough of these death pyramids, we're going to try something new," Ramón said cheerily. "I'd like you to make a skeleton on the Cross."

Inocencio, "Chencho" to his friends, said nothing, but stood gazing out past his patron into the dirt yard, where a ragged hen was pecking intently at a steaming cow patty. A flood of images raced through his mind. He imagined himself at mass among the giggling catechists, head bowed before the scandalized priest, the offending skeleton boxed up and on its way to California. He pictured a fatal blowup with Don Ramón, his most important client, as he tried to explain in simple words why the new order could not be filled. He saw his contract to buy a small vacant parcel torn to shreds, the land sold to another, more accommodating carver. He remembered life before carving, an all too recent past— the sting of the air in far-off Mexico City, where he had spent a year sharpening knives, the long trips

into the sierra with his brother looking for odd jobs, the boredom and exhaustion of day-labor in Oaxaca.

Resolving to talk to the *cura*, Chencho said, "I'll do it, but just this once. How many do you want?"

Authenticity. Indigenousness. These are the flash points in Oaxacan wood carving. Should it matter where the carvers get their ideas and who they work for? Is their art somehow lessened because it has always been practiced for foreign consumption, has always been shaped by exogenous sources, and is barely two generations old? Catching the "soul" of the Oaxacan wood-carver is tricky business. What most inspires him? Hunger? Tourists? Faith? Nature? A good joke? Is he a jobber at heart, or is he profound? Is he lucky or good, heartfelt or bored? From carver to carver, the answers differ.

Miguel Santiago studies farm animals for hours. He watches dogs urinate and bay at the moon, or throws rocks at their feet to see how they move. But then he retreats to his tiny studio to leaf through a ten-volume encyclopedia of the world's fauna. Some of his most graceful, eloquent animals he has never seen, and he considers them no less authentic than his carvings of the pigs that wander outside his door.

"I'm on my own, no one is teaching me, so I get my ideas from wherever I can," Santiago explains. "The silliest little book can show you something."

Inspiration comes from strange places. Some years ago, Jesús Sosa of San Martín went to the doctor with typhoid fever and, flipping through a grimly-illustrated tract on amoebic dysentery, had an epiphany. "I went home and started painting amoebas on my animals," Sosa recalls—and later, perhaps more appropriately, on his skeletons. The splotches have gotten smaller and finer and more complicated since then, but the basic motif remains the same, and it sells. Thanks in large part to a parasite that infests millions of bowels in southern Mexico, Sosa is building his new two-story house.

Next door to Sosa, Coindo Melchor got his bird women from a paperback put out by the government's education ministry. His son, Inocente, takes ideas from calendars and candlesticks, with lyrical results. The other son, Jesús, gets his unicorns from a comic book and his cows from the live models outside his bedroom.

Church icons may be sacred, but most carvers thoroughly enjoy standing biblical iconography on its head to express themselves and earn some money. A crooked branch is as likely to be whittled into a Virgin dancing with Satan as it is Christ bearing the Cross. Voodoo-like crucified devils are made by an old, church-going artisan around the block from Chencho—"My idea," the old man, Ventura Fabián, says proudly. Indeed, Chencho is old-fashioned.

Three types of nativities can be found in San Martín. Carvers make wooden ones to sell; they buy scenes of plastic for themselves; and they assemble a life-sized crèche, for the communal fiesta on Christmas Eve.

Carving one's own nativity would be considered egotistical, Abad Xuana explains. "They'd say we were admiring our own handi-work." Besides, he says, most carvers prefer plastic anyway. It's smoother than wood, it's imported, and it costs a fraction of what most carvers get for their own work. The Christmas party is the most expensive and dra-matic fiesta of the year. Two hundred boys and girls march double-file

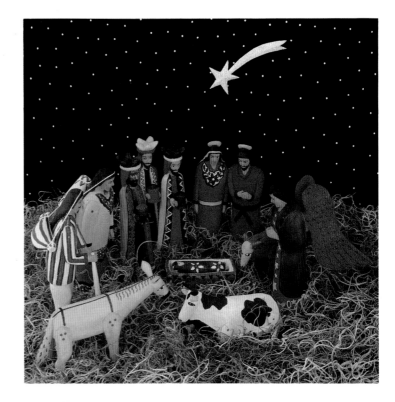

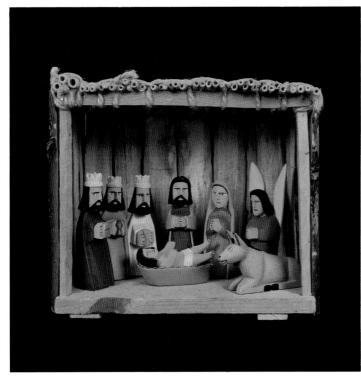

through the village, followed closely by the plaster Christ, carrying tall, decorated boughs, to the courtyard of the fiesta's patron. Two bands herald His coming—one the tradi-tional village band and the other an electric combo. The two groups answer each other in chorus as the Child is clothed in diapers, fitted with a guitar, and nestled amid the twinkling lights, sheep, and pine branches of his temporary home. Four women with huge reed brooms sweep a halo of dust from around the crèche, and two angel girls mount their positions. The ceremony lasts through the night.

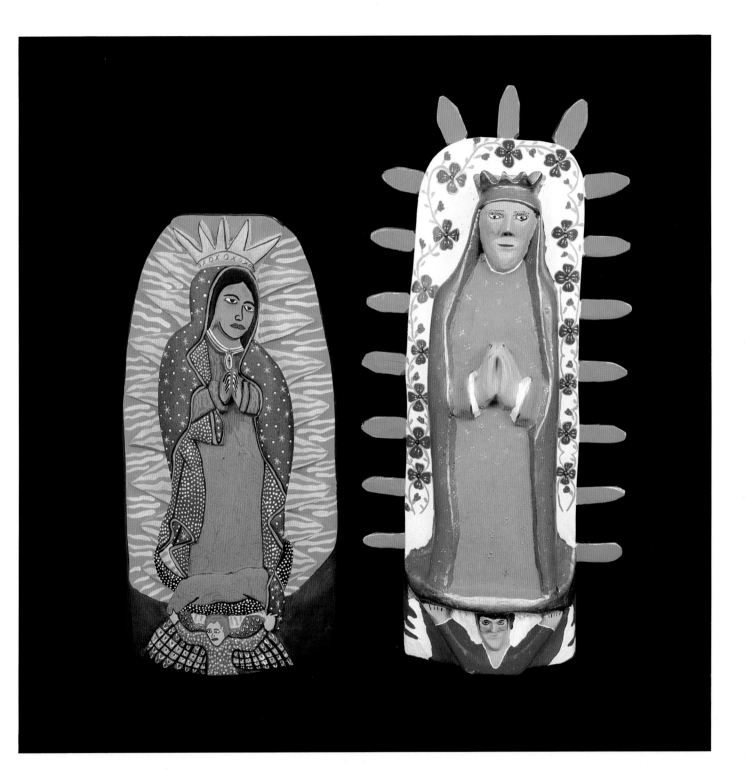

facing page (above):

Nativity

Octaviano Santiago

facing page (below):

Nativity scene

Justo Xuana

above:

Virgins of Guadalupe

Pedro Ramírez (left)

and **Inocencio Vásquez**

The market surely influences the carvers, but "the market" is no less jumbled than the village culture it is transforming. A wholesaler might order a hundred armadillos six inches high, sixty black-and-white dogs, and a dozen snakes ten inches long. A gallery owner may want ten one-of-a-kind pieces to sell to collectors. A tourist might take a few souvenirs to stuff in a suitcase.

The carvers, too, work in different ways, and a merchant does well to choose his supplier carefully. One jewelry-store owner from Vancouver brought down five tablets of Northwest Coast Indian art—sacred symbols from a distant world—and asked the fastidious Inocente to knock off a hundred of each. The jeweler even flew down an Indian artist to show him how. It didn't work. Juan got bored less than halfway through and abandoned the order.

The buyer might have had more luck with José "Pepe" Santiago. Pepe, a skinny, intense fellow, and his wife, Mercedes, a keen businesswoman, have set up a sweat shop in Arrazola, just up the street from Manuel Jiménez. The couple employs seven carvers, seven painters, a full-time sander, and a cook, all from the village. Together they can turn out as many as a hundred figures a week, at bargain prices. "This is not art," Pepe confesses above the roar of an electric sander, flanked by several teenage boys chopping out armadillos. "But we fill our orders."

Provenance in the wood-carver's art has never been much of an issue—not for the artisans, who rarely know the source and symbolism of what they're making, nor for the dealers, who are generally too harried to care, nor least of all for the consumers, most of whom have never been to Oaxaca and who simply buy what strikes their fancy. For instance, one catalog, *Objects by Design,* contains this imaginative bit of sales humbuggery purporting to explain an antenna-covered monster:

> ZAPOTEC MARTIAN. Legend has it the ancient Zapotec Indians lived in peace with visitors from outer space. In his studio in Oaxaco [sic], Mexico, Porfirio Sosa Gutiérrez handcarves and paints these wooden time travelers to bring good luck to your home or office. 8 inches high. $55.

Of such legends are profits made and history lost. In fact, the figure is called an *alebrige.* It was first created by a papier-mâché artist in Mexico City, the late Pedro Linares, who also invented its name. According to Linares's family, the thing came to him not from Mars or points beyond, but in a fever-induced nightmare. Nor did he consider it good luck; quite the contrary, it scared him.

Piggybacking on Linares's popularity, folk art merchants in recent years have grafted the *alebrige* onto other export crafts, including Oaxacan wood carving. It is no more Zapotec than was its creator

or its most industrious copier, Sosa. (Both are mestizos, Mexicans of mixed Indian and Spanish ancestry.) As to the legend that the Zapotecs lived in peace with visitors from outer space, it is as fanciful as the carving that inspired it. The Zapotecs are not known to have lived peaceably for very long with anybody.

(Issues of authorship—of who actually makes a piece—are just as cloudy. Even collectors of Manuel Jiménez can't always be sure of whose work they are getting. One carver tells about his years working at a government-owned crafts store in Mexico City during the 1970s. "We'd get these big orders for animals by Jiménez, and a lot of times we didn't have enough in stock, so I'd just take any figures that weren't signed and write his name on them," the carver, who worked as a packer, recalls. On more than one occasion, pieces carved by Xenén Fuentes of San Martín left the store as the work of Don Manuel simply because Xenén had been too afraid of the taxman to sign them.)

Even without prodding from their clients, carvers borrow liberally from the older crafts. Abad Xuana says he got the idea for his animal musicians while working in the same government store, Fonart, which sold similar figures in clay. Motifs from pre-Hispanic stone-workers and ceramists also pop up in the carvings, although considering that images of pre-Columbian art are splashed throughout Mexico—in museums, subway stops, grade-school primers—the carvers might adopt these unconsciously.

In San Martín, many of the best painters of carvings are women who developed their sense of color and pattern by sewing *vestido bordado*—the fad of the 1970s. "But in fact, this is much harder," María Jiménez (no relation to Manuel) says. "Carvings are three-dimensional, so they're much more complicated. Blouses are just flat."

It is easy to imagine a great painting, Yeats once said; the hard part is realizing it in materials. Inspired, stolen, or imposed, "an idea is simply an idea, and anyone can have one," Jaime Santiago says. "It is the artisan who must use his talents to give it life. People can spout great ideas all day long, but most of them never leave the cantina."

Indeed, the singular genius of the popular artist in Mexico is his and her ability to make so much with so little, to spin out a thousand variations on a single theme, to convert the cheapest materials with the simplest tools into something so magical.

The tools of the carver are as plain as his inspiration is eclectic. Ninety percent of the work is done with machetes and kitchen or pocket knives. The wood comes from the *copalillo* tree, a rather ugly-looking, small-leafed hardwood that once grew in abundance on the hills around the Oaxaca valley. "It

was a fourth-class wood," good for nothing until carving came along, Epifanio Fuentes says. Having denuded their own village forests, carvers must now pay dearly to have the wood trucked in from the mountains.

The advantages of *copal* are several. When green it is soft and easily workable. It has a small heart so does not split easily. It sands to a smooth, porcelain-like finish. And it does not absorb much paint.

Its main disadvantage is its susceptibility to bugs, particularly the powderpost beetle, whose eggs can lay dormant for years. (The beetle destroyed Nelson Rockefeller's entire collection of Manuel Jiménez figures while they were packed away in storage.) Carvers thus must turn over their inventories quickly; any wood that stays in the villages for more than a few weeks runs the risk of being eaten to dust. Buyers and artisans often inject figures with gasoline, but this does not kill the eggs. We have had luck putting our pieces in the freezer, but they must be kept there for a minimum of a week, preferably two. Some carvers also insist that branches cut under a waning moon have fewer beetles, and instruct their suppliers accordingly.

Most figures are carved within a day or two, and the shape of the branch to a large extent dictates what can be made. The wood is knotty, and gashes are common. Abad Xuana, a lithe, sinewy farmer with a youthful face, once sliced into his wrist and narrowly missed a vein, which popped up whole out of his arm. He pushed it back in, bandaged the wrist and resumed carving the next day. He was a novice at the time, he explains. Chencho Vásquez has eight scars, from three different tools, around his left thumb. Jesús Sosa carves only during the day so that if he cuts himself badly, he can get to a hospital. (There is no bus service to the city from San Martín at night, and Sosa does not have a car.)

Knives must be filed daily, sometimes two or three times a day. "The sharper your knife, the less likely you are to cut yourself," Abad's son Antonio insisted as I was about to carve my first and only figure, a little shepherd. Antonio, assured, direct, and roguish like his dad, has a flawless technique, vivid imagination, and lots of experience teaching his friends to carve. It didn't help: I sliced off the tip of my index finger within half an hour. (Lucky for me I did this under a waning moon; blood, like the beetle, apparently, flows more during a young moon.)

Two liquids are recommended as 100 percent effective to stanch the bleeding in a nasty cut. One is gasoline—in Mexico it's usually leaded. The other is urine, preferably one's own.

Once carved and sanded, a piece is adorned with the simplest of materials. Ventura Fabián cuts the hair off his nine-year-old son, Beto, to make his paintbrushes and uses a single strand of it for details. "My hair's too curly; his is perfect: straight and thin, and it lasts for years," Ventura explains. He glues clumps of goat hair from his own herd down the backs of his wooden goats and pigs, and snaps

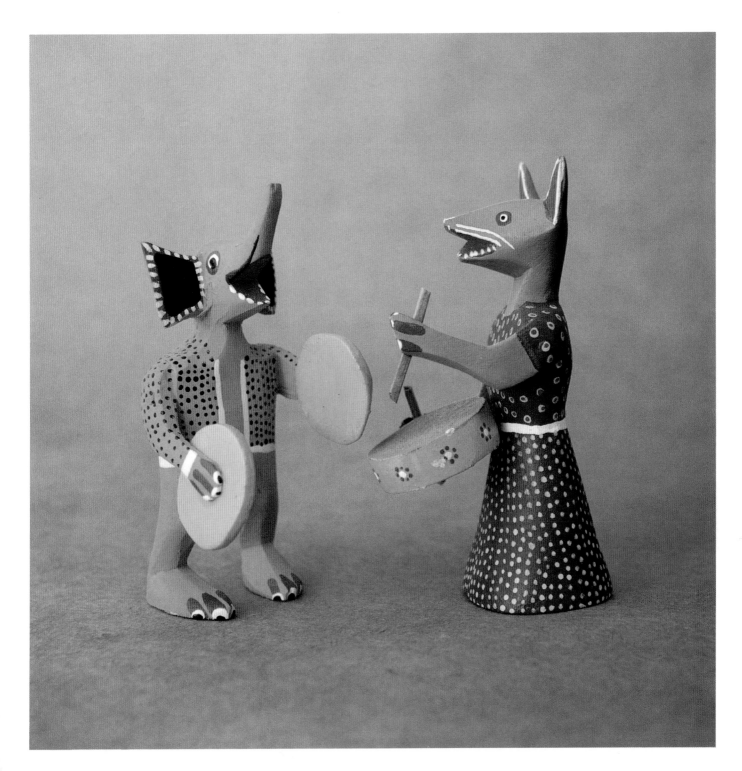

Musicians

Abad Xuana

off cactus spines for their teeth. Gabino Reyes, a thoughtful, introspective, otherwise impractical sort, keeps a sow in his front yard and uses her hair for the tiny whiskers on his armadillo families; he clips hair from the neck of his donkey to make his paintbrushes; he paints his crocodiles with sticks. Manuel Jiménez has used *totomozle*—dried corn husk—to swaddle the Baby Jesuses in his nativities. Porfirio Sosa collects shoelaces to tie his oxen teams. Epifanio Fuentes and Jesús Sosa top their angels with a full head of *ixtle,* fiber pulled from the leaves of the maguey plant.

Carvers used to paint with water-based aniline dyes, but most switched to shiny acrylic house paints in the mid-1980s when buyers complained that the dyes fade. (The dyes also have been linked to bladder cancer, although for folks who dip their wounds in petrol, this is not an issue.) The acrylics come in a greater variety of colors, and carry names like dolphin green, sunkist orange, and jungle blue.

Why are there so many good carvers in Oaxaca? Why did we find seventy carvers—many of them new to the craft—whose work we liked enough to buy? The drive comes from necessity. "All crafts are born out of hunger," Arthur Train says. "When people make things with their hands here, they don't do it for the love of art, they do it to forget their troubles and to eat."

The talent comes from opportunity. "Carving is in a peasant's blood," says Alejandrino Fuentes, a trained engineer who left his profession to carve. "A peasant carries his machete like a friend, as a student would carry a pen or a book. It's indispensable. If you're ploughing, you take it to cut roots. If you're herding, you take it to clear the path. You take it with you to go to the bathroom. Why? Because you're in the fields, and there's always the chance that you'll run into a snake." Or for that matter a witch or a demon—against whom a machete is considered the best defense.

"Kids are out in the country with nothing to do. You sit there watching the animals eat grass. Sometimes you're in the shade of a tree, and maybe you see a branch that looks like an animal—let's say a monkey. Purely by instinct you cut it down and start to whittle. You do it to pass the time, so that you're not out there falling asleep. But that's where the inspiration begins, that's where wood-carving is born: you have your machete, the figures are there in the trees, and there's nothing else to do."

The final requisite for any crafts renaissance, of course, is a buyer. Talent notwithstanding, the carving boom has always been dealer-driven. Wholesalers have scoured the villages—bartering Reeboks and VCRs and cassette players for figures, bringing in high-quality tools, leaving behind picture books, drawings, and suggestions.

How long will it last, this serendipitous interplay of market forces and creative spirit? Sales peaked in the late 1980s and have been hurt since by a sick U.S. economy, a gradual revaluation of the

right:

Blind man sanding

lower right:

Copal vendor

lower left:

Kitchen knives used

for carving details.

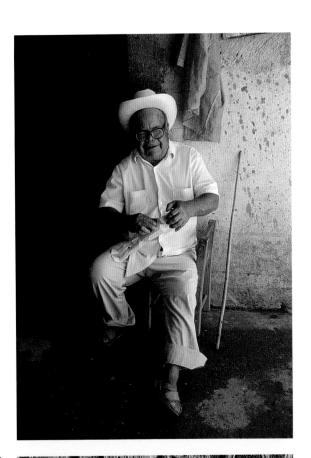

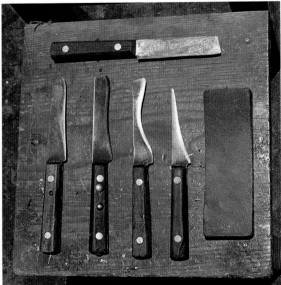

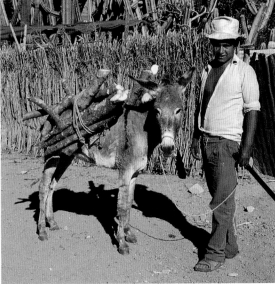

peso, and price increases by the carvers—who do not understand market forces, hence cannot see why prices should be moving in the opposite direction. Many dealers have stopped buying entirely and are looking to the Pacific and the more impoverished Latin nations for bargains. Who knows? Perhaps ten years from now someone will write a book about the great carving boom in Bali, where people are also talented and prices are still low.

Faced with declining sales, a few more carvers have sneaked into California. Others have gone back into construction, Oaxaca's principal source of jobs. Most keep at it, if only for lack of any alternative. One of my most vivid memories from Oaxaca is of a crippled old man, alone with his bright-eyed granddaughter, propped into an armless, straight-backed chair in a dark hut, whittling away at a feather dancer with his one good hand. He managed this by wedging the wood between his legs and shaving it by tiny degrees with a kitchen knife. Santiago Sosa was his name, and when I met him he had sold exactly fifteen pieces in his career. At the time, he was the only carver in San Martín still making Indian *pluma* dancers. The rest had caught on that, although the *danza de la pluma,* a reenactment of the Conquest, is San Martín's official dance, the plumed figure was not a hit with the Americans. The carvers abandoned him with alacrity. Within weeks of my visit, Sosa had forsaken him, too.

The pitiable determination of this old man as he tried, however feebly, to seize what must have seemed like a miraculous opportunity—to break out of poverty! so late in life!—gives one a sense for what life was like during the most frenzied years of the carving boom. It was like living in a time of revolution, a time of great efforts and surprising events and sudden shifts of fortune, pregnant with the sense that anything was possible. It is still, for some of the carvers.

Jesús Sosa, no relation to the old man, finishes his amoeba skeletons on schedule, often staying up all night to do so. Like so many poorer Mexicans, Sosa is *miluso*—literally, a thousand uses—and has bounced through a long string of jobs, each one ended by forces beyond his control. Since 1981, he has been an electrician, has worked two government jobs, and has raised, butchered, and cooked pigs. He keeps bees. He was unemployed or underemployed for three years, during the worst of Mexico's crisis, until he caught typhoid and began carving. He is thirty-five.

"This work has been a blessing from God," he says, "but who knows how long it will last? That's why we have to work night and day. Frankly, I don't have a day of rest. We never stop working. While I sleep, my wife paints. I'm trying to finish my house. When the buyers stop coming, I want to at least have the house as a memory."

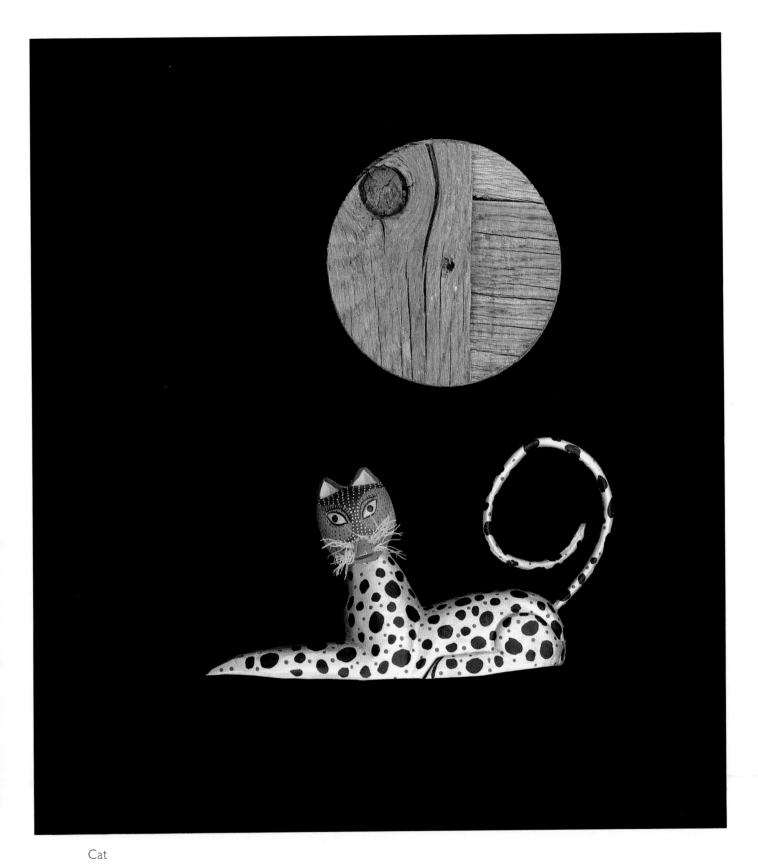

Cat

Jesús Sosa

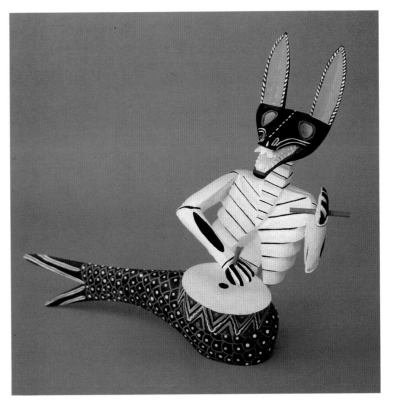

Coyote/skeleton/ mermaid

Antonio Xuana

FIESTAS

Fiestas are the fullest expression of a Oaxacan's belief in the promise of magic, of fable, of something stronger than death. Inspired by Catholic faith, ensured by webs of obligation, fiestas unite a village with the fervor of a holy war. Toothless, rheumatic old women volunteer for days of round-the-clock duty, working through the night to prepare great caldrons of liver-and-egg soup, black *mole,* and hot chocolate—enough food to feed hundreds of people for days. Brigades of adolescents sacrifice their evenings to prepare long streamers of paper cutouts and plastic flowers. Commissions of men are appointed months in advance to go house to house collecting money or pledges of food.

We're real *fiesteros,* Oaxacans say, party animals. Hardly a week goes by in a village without some orgy of consumption. The list of fiestas is eye-popping. There is Christmas, Easter, Carnaval, Three Kings Day, All Souls' Day, Independence Day, Constitution Day, Benito Juárez Day, and Workers' Day. There are days for the saints, days for the Virgin, days commemorating military victories, days commemorating defeats, days for teachers, masons, and mailmen, days for doctors, architects, and journalists. Finally, there are the rites of passage: an endless parade of weddings, baptisms, birthdays, confirmations, *quinceaños,* and so on, all cause for extended celebration.

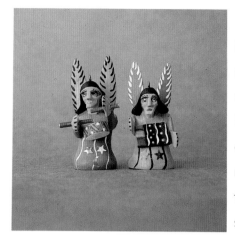

Fiestas shape a wood-carver's sensibility in obvious ways. Every fiesta is accompanied by the village band, so carvers make musicians—often they *are* musicians. Bingeing is common at fiesta time, so carvers make drunks. For Carnaval in San Martín, boys coat themselves in tractor grease and dress up as devils, so carvers make devils. Every town celebrates its own manifestation of the Virgin Mary, so carvers make Mary. Ancestors come back to dine on the Day of the Dead; carvers make skeletons.

Epifanio Fuentes is renowned for his serene, robed angels, and one need not look far for his inspiration. On days honoring San Martín's patron saint, little girls are dressed as angels and paraded on a float through the streets. A queen angel, known as the *madrina,* bears a floral offering to the statue of San Martín in the church. This honor recently fell to Epifanio's seven-year-old daughter. Shortly after birth, she underwent surgery that cured a crippling spinal defect—miraculously, Epifanio now says. As a pledge of gratitude, he put her on the waiting list to be *madrina.* And he named her—what else?—Angélica.

The waiting list for *madrina* extends into the twenty-first century and is filled with girls who have witnessed miracles or survived calamities or whose parents are simply devout. Promising one's daughter obliges one's family to host an enormous fiesta, and not the least of San Martín's miracles is that carvers who made their pledges years ago when they were dirt poor have since grown rich enough to host these affairs without going into debt for a lifetime.

In most cases, fiestas are as wholly based on borrowing as a leveraged buyout on Wall Street. No other activity consumes a greater portion of a village's savings. The host of a wedding, for instance, might ask his neighbors to "lend" him, interest-free, a turkey, a carton of beer, and a day of music from the village band. In theory, these "loans" are backed by the debtor's possessions and are callable at any time. In practice, they are about as secure as a pyramid of junk bonds. Many a *fiestero* has gone to his grave owing chickens, soda pop, and mescal to the impoverished multitude attending his funeral.

Fiestas are among the few occasions in rural society when the sexes may flirt openly. In San Martín, one of the more elaborately choreographed excuses for courtship is the Parade of the Boughs on Christmas Eve. A hundred boys are driven three hours across the Oaxaca valley, then climb another two hours into the mountains to cut the tops off a hundred trees. After returning home, each boy is

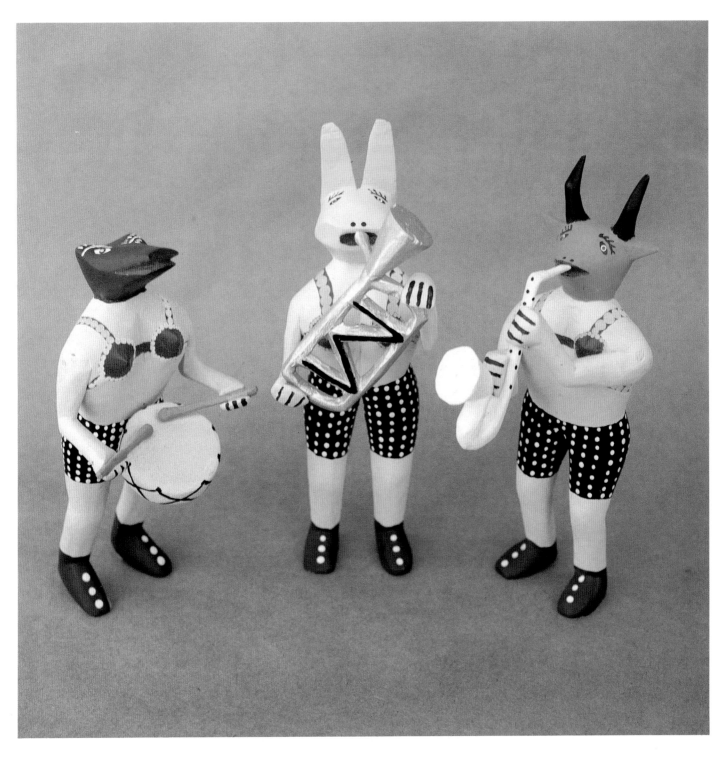

facing page:

Angel pair

Adrián Xuana

above:

Trio

Melchor Calvo

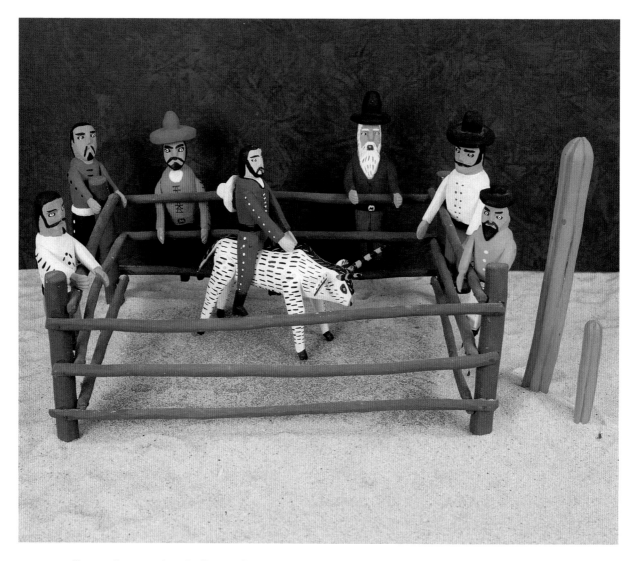

Fireworks are a daredevil sport in Mexico. Papier-mâché animals loaded with pinwheels of gunpowder are danced through the crowd before the church at fiesta time. Fireworks are also a form of communication; bottle rockets punctuate each phase of a celebration, and the man who throws them skyward must time them perfectly. Guests, hosts, and musicians, wherever they are, don't check their watches before springing into action; they listen for the explosions.

above:

Rodeo

Miguel Ramírez

facing page:

Fiesta scene including

bull loaded with

fireworks.

Jaime Santiago

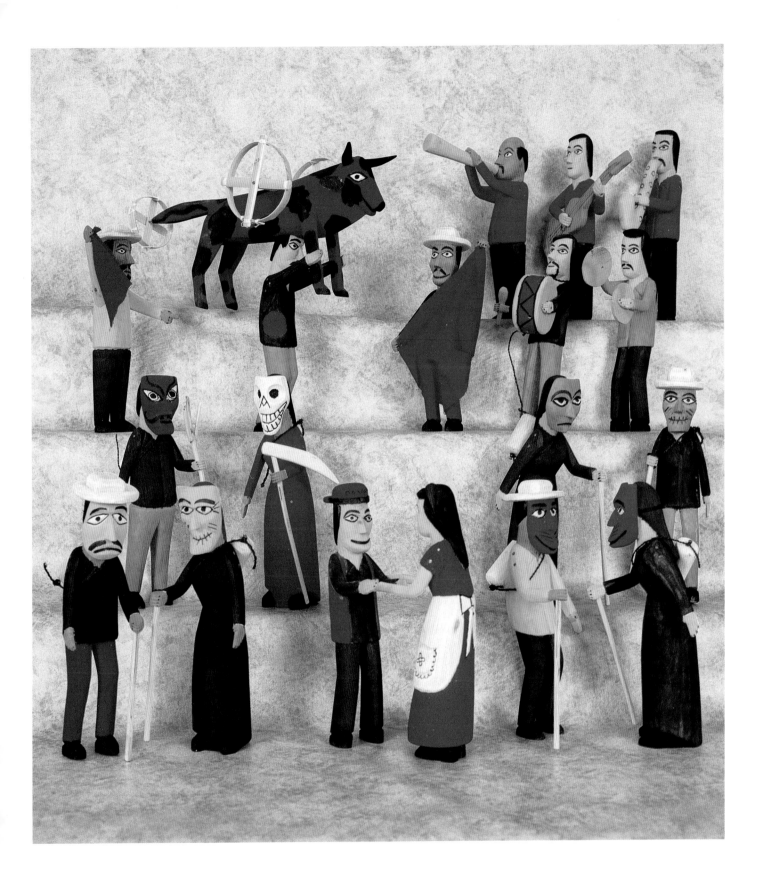

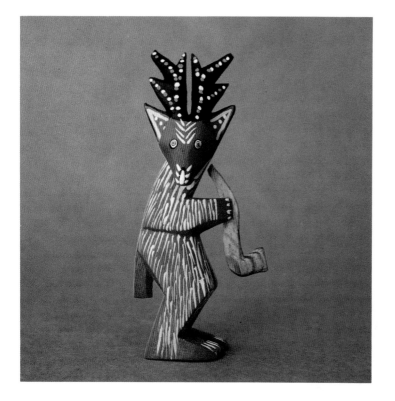

Most village bands comprise amateurs who simply could not get through a tune without a drummer. On fiesta days, the percussion section holds together more than just the musicians—it marks time between events, serves notice that festivities are in progress, and heralds acts to come. All day long and into the night the drummer beats, for as long as the fiesta lasts. Along the unpaved streets he beats, hurrying stragglers to the party; while the band rests he beats, filling space between the songs; alone before the church he beats, guarding the angels inside.

above:
Deer dancer with
cedar saxophone
Justo Xuana

right:
Duck
Adrián Xuana

paired off with a girl, who decorates the bough with balloons, flowers, and candy. Boys, girls, and boughs then proceed double-file up and down the streets, through the church, and finally into the house where the Christmas fiesta is to be held. The parade lasts more than an hour, by which time, the boys say, you've had lots of time to enjoy the romantic swish-swishing of balloons in the breeze, but you're also too tired to do anything.

On days honoring San Martín, the village's corps of available young women put on their finest clothes, braid their hair, and bring flowers to the house of the *madrina,* arriving by twos and threes in the late afternoon. A thumping drumbeat heralds their coming. The girls line up on long, skinny benches—flowers in one hand, a bottle of pop in the other, moms seated firmly behind them. There they wait, drum still thumping, as their reluctant suitors poke about the courtyard entrance, straddling bicycles and giggling in cracked voices.

We are Catholic by day and Zapotec by night, Mexicans like to say. Nowhere is this split more evident than at a fiesta. A drunk stumbles across the dirt dance floor, collapsing in a pool of spit near a group of angels, young tendrils of Christ, who chatter on unperturbed. Thick, short men swear and scuffle inside the host's courtyard, while outside a truck is festooned with flowers to carry the queen angel to church. Señoritas laden with flowers glide past men urinating into the bushes or against adobe walls. By nightfall the steady drumbeat of the village band has decayed into an erratic pulse, the drummer and his friends reeling from mescal. The musicians drowse through the fireworks, which are launched by hand by the church door, illuminating in red, white, and green the little angel faces filled with wonder. Such are the scenes a carver grows up with. His carvings seem not at all fantastic to him.

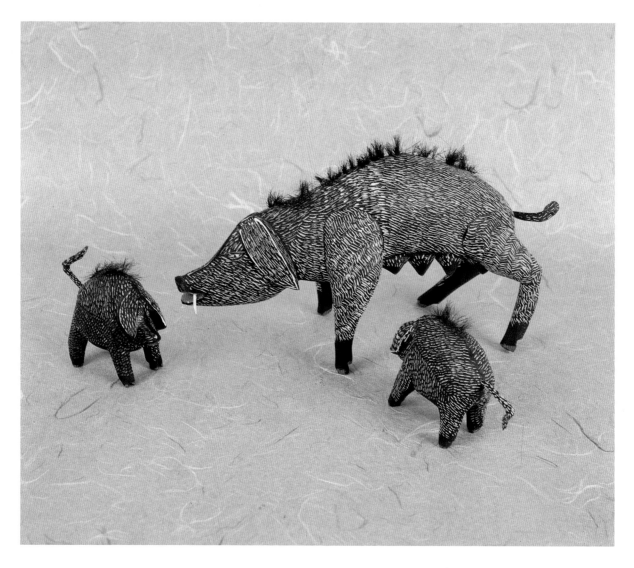

above:

Pigs with goat hair

Ventura Fabián

right:

Drummer

Ventura Fabián

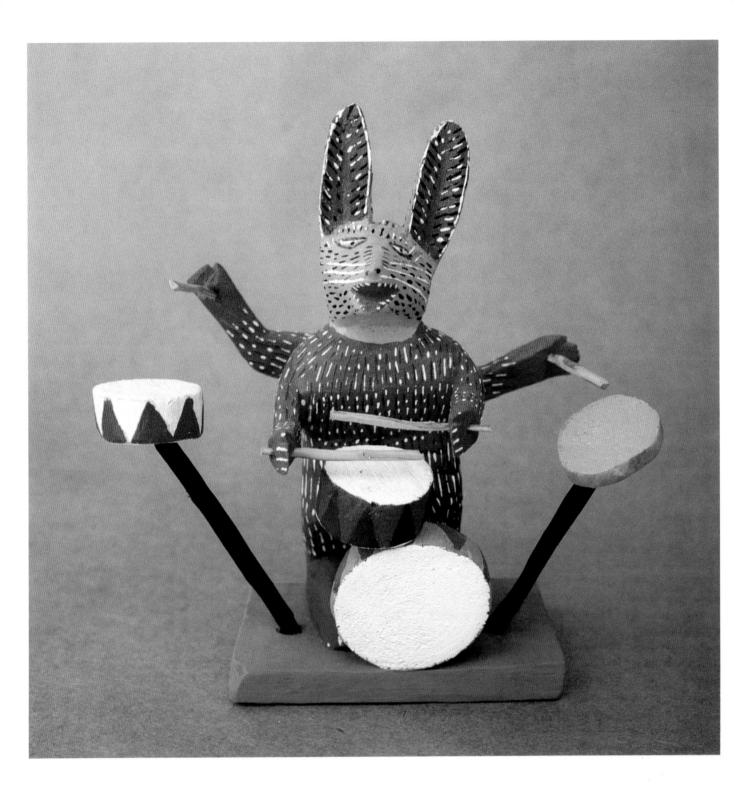

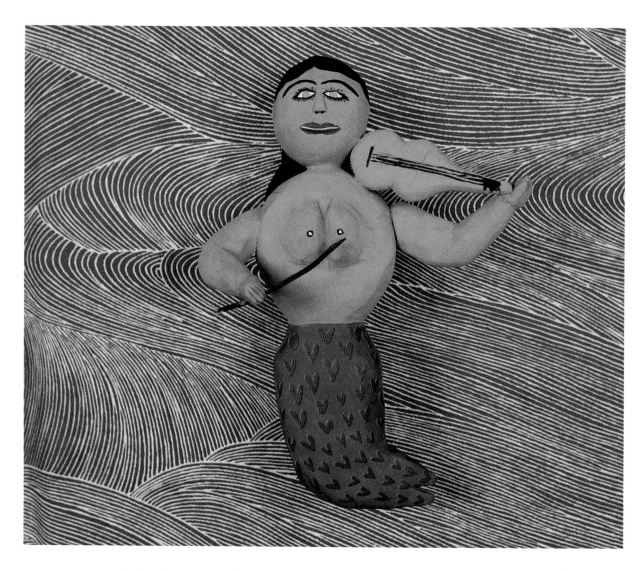

A carver's first pieces tend to be naive, crude, eccentric, and more interesting than what he makes once he has absorbed the conventions of his neighbors and buyers. Technique improves, but the pieces somehow become less expressive.

The early carvings evoke the rawness of modern art, the aesthetics of which most buyers have thoroughly, if subconsciously, absorbed. But the carver himself knows nothing about modernism and, what is more, explicitly rejects its ideals. Realism is almost always his goal, and the closer his technique carries him toward it, the gaudier his work seems to "serious" collectors. Conversely, what may attract us to his early figures—oversized eyes and breasts, too long a neck, a tense stiffness of form, and so on—are often the very things the carver views as errors to be corrected.

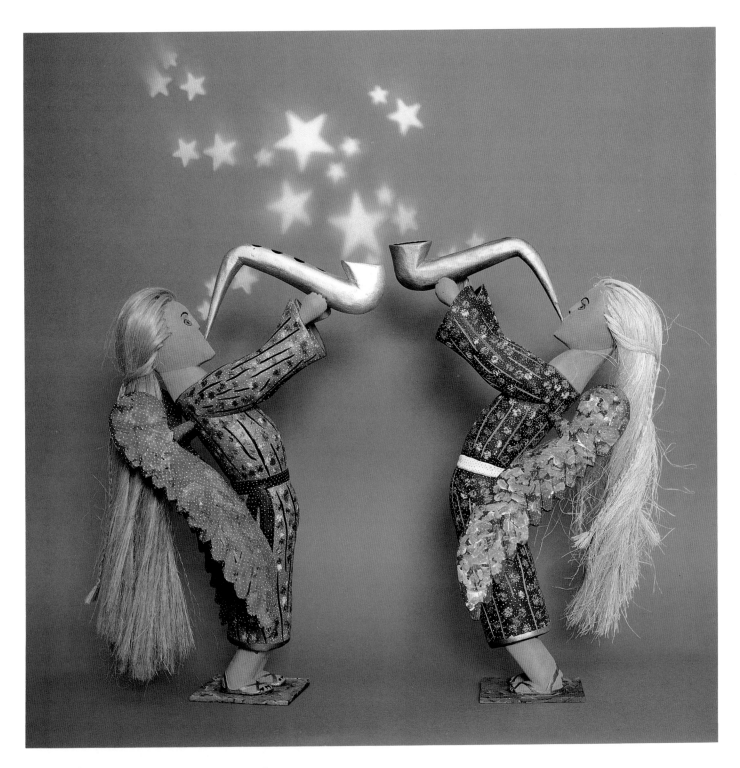

facing page:

Mermaid

Catarino Cantor

above:

Angel pair with dyed

ixtle hair

Jesús Sosa

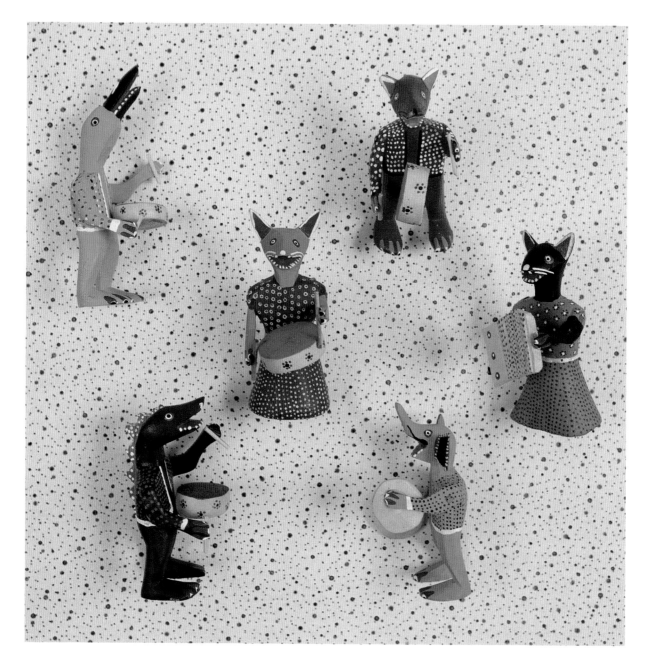

above:

Animal musicians

Abad Xuana

facing page:

Drummer trio

Adrián Xuana

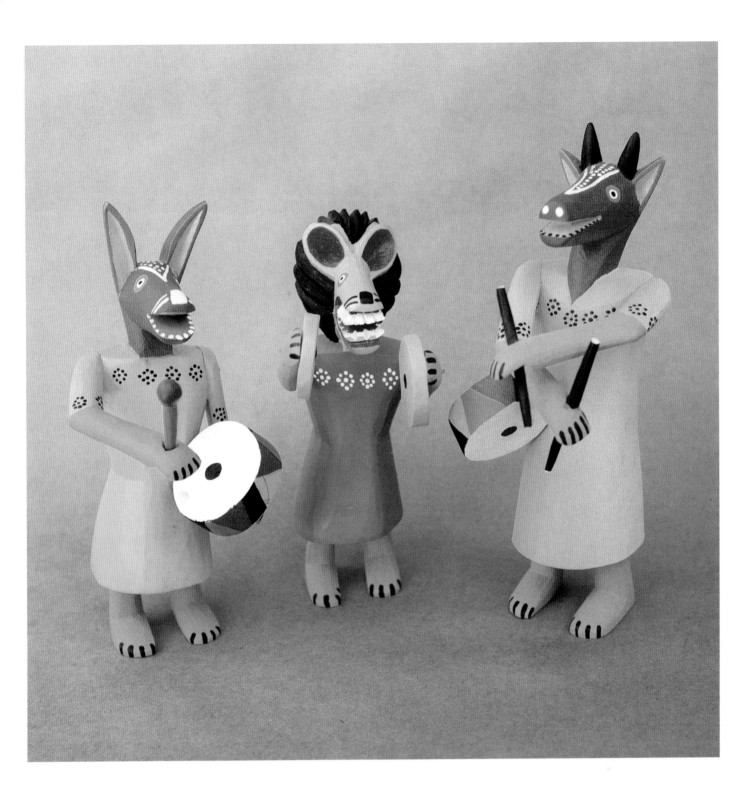

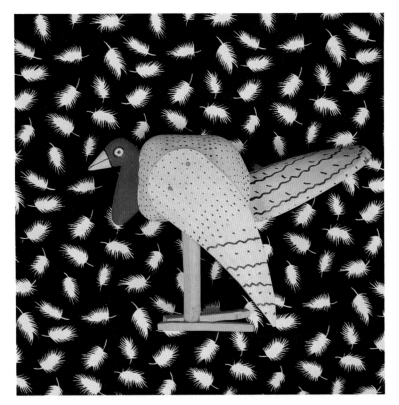

Turkey

Erasto Ramírez

NATURE

Xenén Fuentes has been carving for twenty years. Every day, he walks two miles into the mountains to take his flock of goats, burros, and cattle to pasture. While they eat, he sits under a guaymuche tree and carves. Every so often he puts down his machete and whistles through his fingers to scare off the coyotes. Time is marked by the sun and by the jets overhead, whose schedules he knows by heart. "Every day, I make an animal and take care of my animals," he says. "It's my homework. The country is my home."

At age sixty-eight, Xenén is the Abraham Lincoln of San Martín, by general acclamation the best president the village has ever had. Using a potent blend of oral persuasion, moral authority, and mescal, he cajoled his fellow citizens into building a small bridge over the creekbed outside town. That was in 1980, before the village was receiving many visitors. Without the bridge, the tourists and wholesalers who now come every day would have to wade across to the carvers during the rainy season.

Xenén and the rest of the carvers of his generation have spent their lives close to nature. Sun, water, land, and animals shaped Xenén's days before the great carving boom, and they shape them now—even as his sons fly the great jets, whose schedules he has memorized, to galleries in the States.

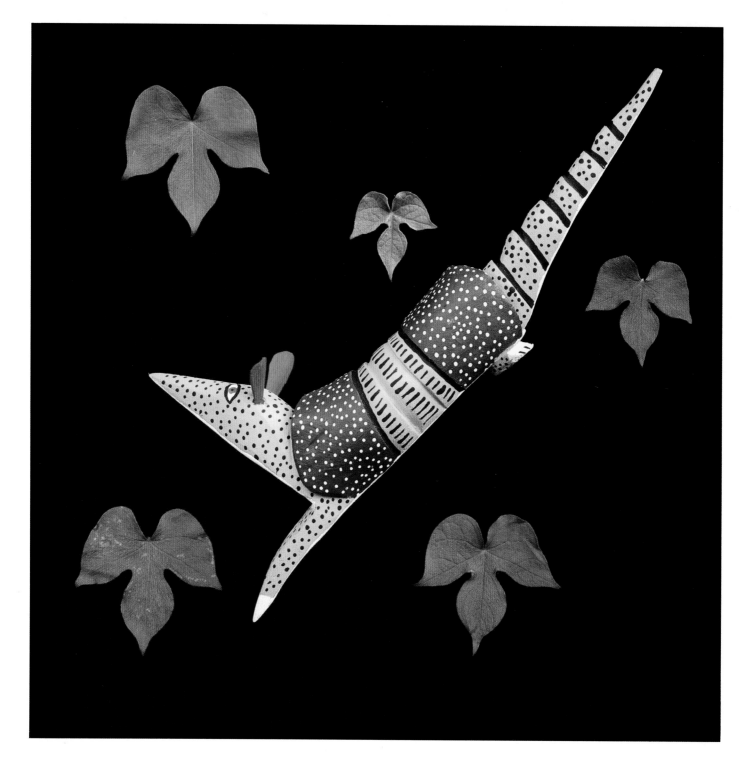

above:

Armadillo

Alejo Morales

facing page:

Large rabbit

Miguel Ramírez

Small rabbit

Miguel Santiago

The older carvers, no matter how successful, all continue to grow their own food, carry their own water, herd their own animals, and battle the desert elements as their fathers did before them.

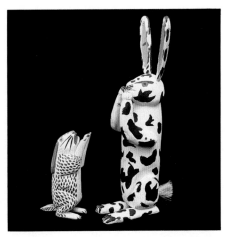

"We do it out of habit," Xenén says. "It's not a good business. It's more like a sport, or maybe a vice." Growing staple crops (the only kind most small farmers know how to grow) makes less economic sense than ever. Water tables have sunk drastically in recent years due to population growth and deforestation. Erosion and chemical fertilizers have exhausted the soil. Real prices for corn and beans have fallen; the cost to produce them has risen.

In the 1940s, Xenén recalls, a peasant could sell two oxen teams and have enough money to build a house. Today, four teams might bring enough to build one room. Fifty years ago, a farmhand might be paid with a half-bushel of corn for a day's work. Today, he commands a daily wage sufficient to buy six times that. Few peasants have that kind of cash—they certainly can't raise it by selling corn—so they must work the land themselves.

Many of the younger carvers understand that herding and subsistence farming are dead ends, especially when practiced on sterile lands and without irrigation. Their fathers, however, know little else. Xenén's cousin, Coindo Melchor, left school after the fourth grade to work in the fields. During the carving boom, he had enough business to carve full-time, but he could not bring himself to part with his animals. He keeps his three head of cattle at a loss, and it drives his college-educated son crazy. "What will I do around here when they're gone?" Coindo often asks, referring to each bull by name. "I'll be lonely." Coindo's wife, Eva, is equally attached to her chickens, which are also maintained at a loss. "I'll sell my cattle if she sells her chickens," Coindo says, smiling because he is setting a condition he knows will never be met. And so, rather than abandon tradition, the Melchors put up with hens scattering the garbage heap, cows flooding the courtyard with dung and urine, and clients, thrilled to be so close to nature, tracking it all into the house.

Living with nature means more than living with animals. It means waking at 5:00 A.M. and going to bed by nightfall, sharing water with anyone who asks and fighting with rifles over a strip of land, foraging the hillsides for firewood and filling the bedroom with corn, killing snakes with rocks and fighting brushfires with machetes, digging wells by hand and hauling tons of water. It means praying for rain,

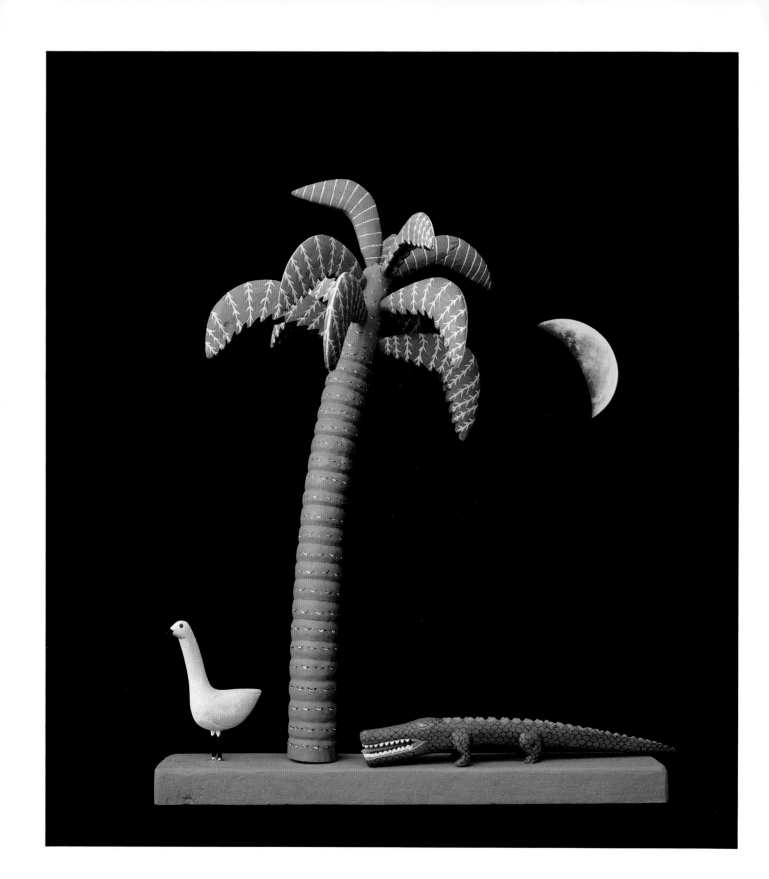

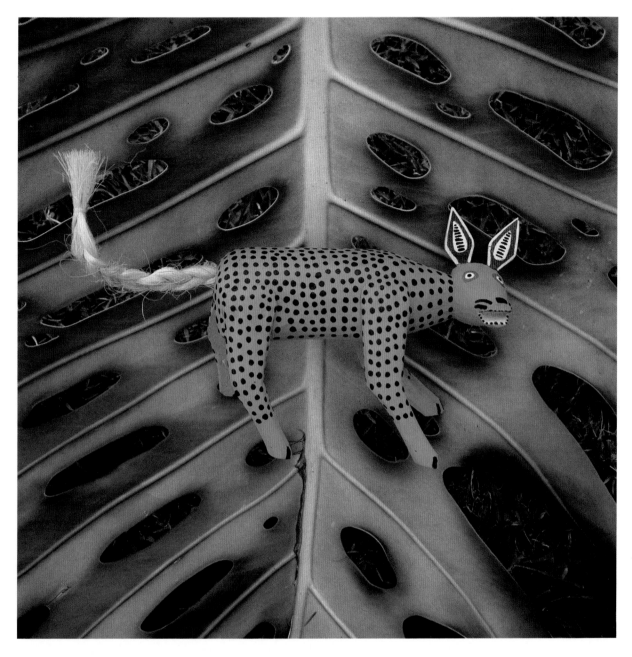

facing page:

Crocodile scene

Aguilino Garcia

above:

Dog with ixtle tail

Antonio Xuana

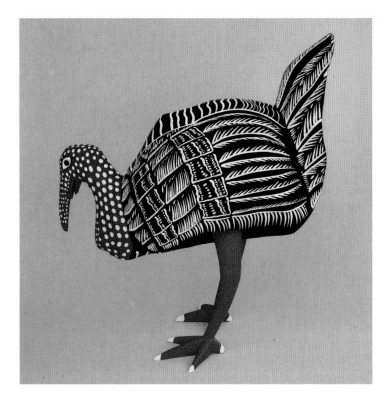

facing page:

Gazelle

Gabriel Torres

above:

Turkey

Moisés Jiménez

right:

Chicken

Blas family

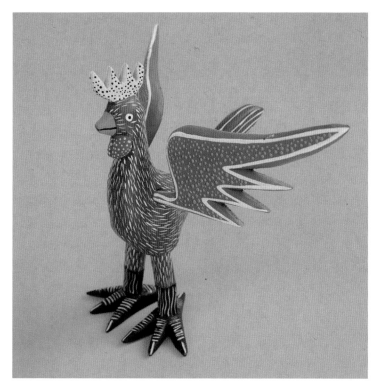

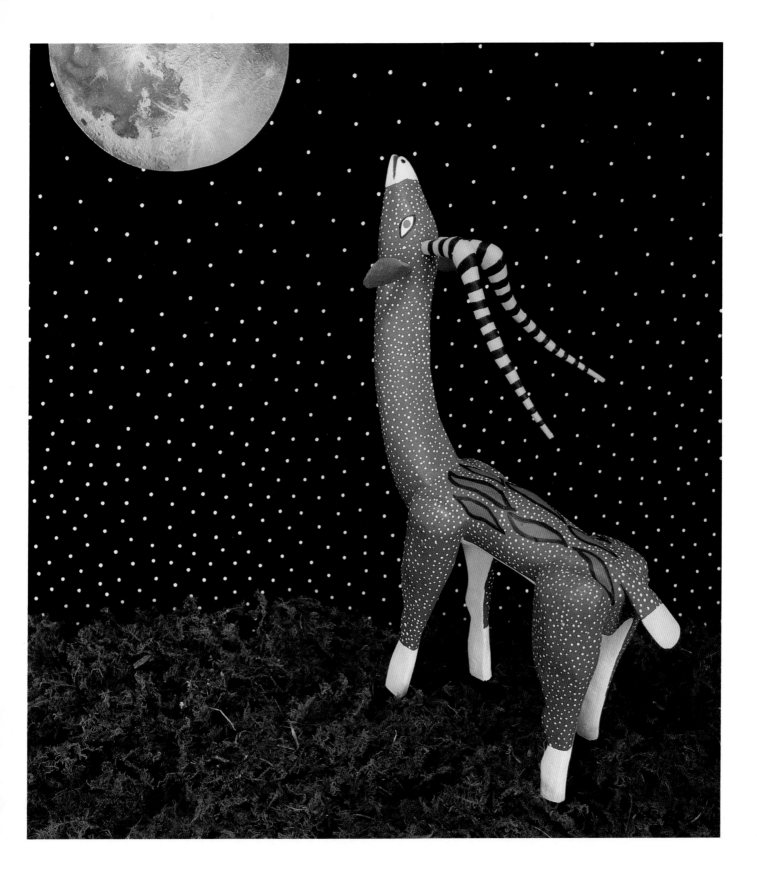

ploughing in lightning storms, picking the crops by hand, and dulling the pain of it all with mescal. It is why Coindo's son washes dishes fifteen hours a day in New York.

Remarkably, the carving boom has not done much yet to upset this agrarian routine. Nor is it entirely accurate to say that Xenén and his generation are staying close to the land while their children are breaking away. In La Unión, young carvers spend more on irrigation pumps and insecticides and seeds than they do on their homes. In San Martín, Chencho Vásquez took the money from the sale of his first skeleton and bought a goat. Margarito Melchor bought his farmland. Most carvers still farm, and they note that each calling helps the other. "Carving defends us in the fields," says Eleuterio Calvo, one of San Martín's wiliest farmers. "We're no longer so desperate for money that we have to sell our corn with everyone else for next to nothing. Now we can live off our carving while we wait for a better price."

Likewise, most carvers who farm say they would go crazy if they had nothing to look at but four walls and a patio and a book of illustrations all day long. Corn and cattle are not the only things that flow in from the countryside. Ideas do, too. Indeed, if carving survives as anything more than a passing fancy in the United States, it will be because the carvers put aside their clients' well-intentioned picture books long enough to remember the one thing most Americans have lost and would love to recover, the one thing Oaxaca cannot export: the daily blessings of nature.

María Jiménez is famous for the florid patterns she paints on her brothers' carvings. No painter in Oaxaca has a more distinctive style or is more in demand. Like so many others, María started out by copying her neighbors and covering her figures with polka dots. They sold poorly. "But then," she recalls, "one morning we went out into the fields. It was a beautiful day . . . barely raining. The desert looks wonderful in the rain. There were flowers, green leaves, yellow stalks, so many colors. And I asked myself, 'How can I do it like this? How can I paint like this?' That's how it started. That's how we all start, probably—by seeing the beauty around us."

right:

Armadillo family with

pig-hair whiskers

Gabino Reyes

below right:

Rabbit family

Sergio Santos

below left:

Dogs

Rodrigo Cruz

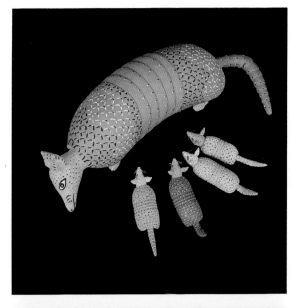

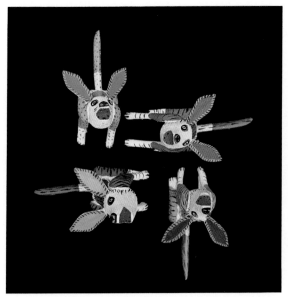

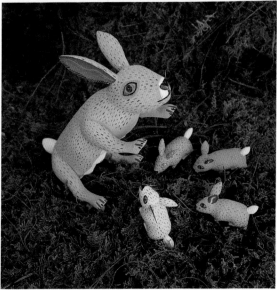

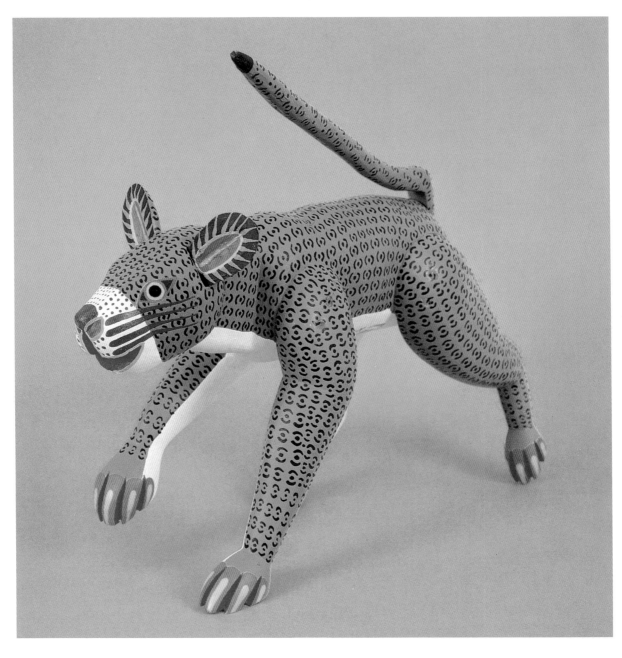

above:

Cat

José Hernández

facing page:

Dog

Pedro Ramírez

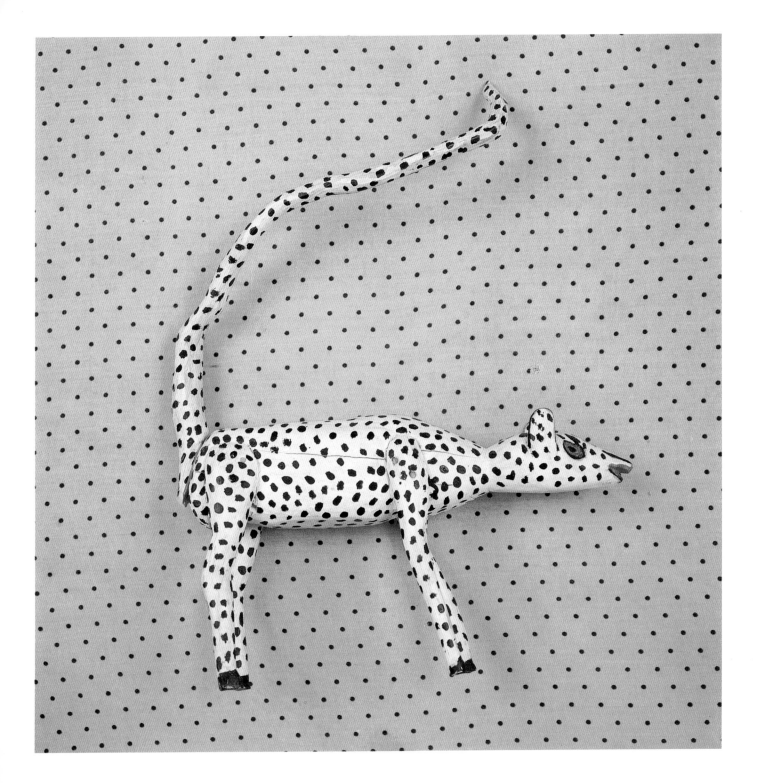

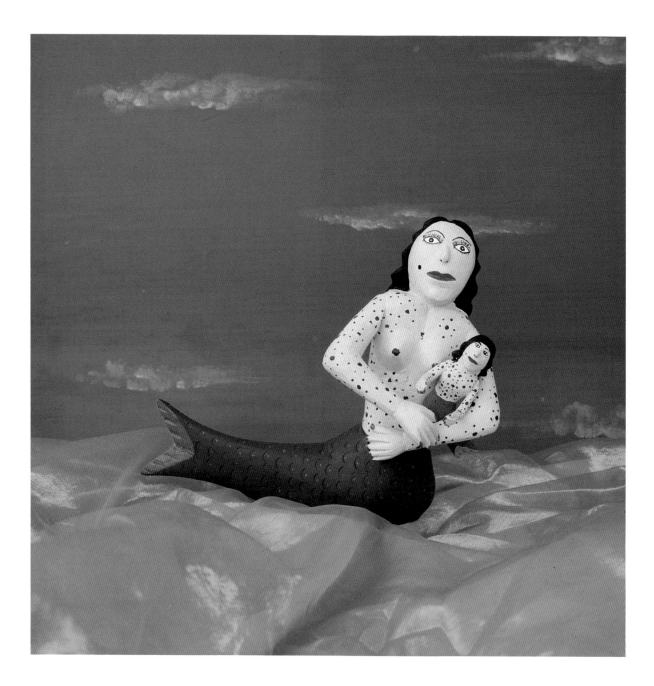

above:

Mermaid with baby

Coindo Melchor

facing page:

Mermaids

Miguel Santiago

Palm tree

Aguilino Garcia

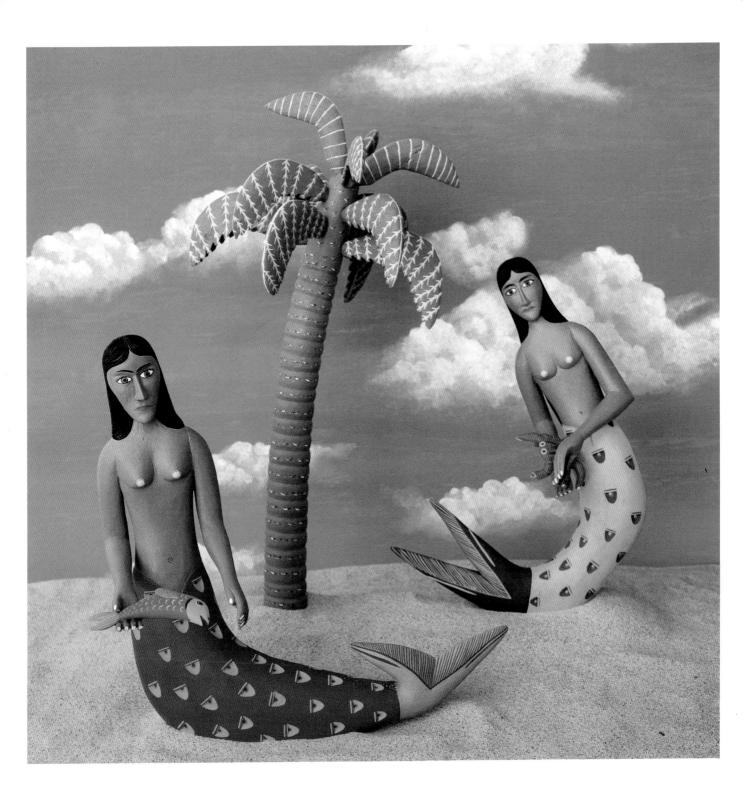

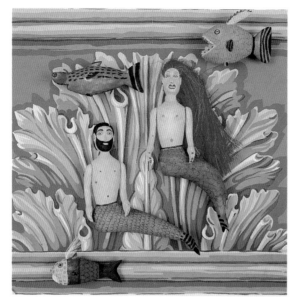

left:

Mermaid and merman

with fish

Alfredo Cruz

lower left:

Mermaid with dyed

ixtle hair

Epifanio Fuentes

lower right:

Mermaid with conch

Gabino Reyes

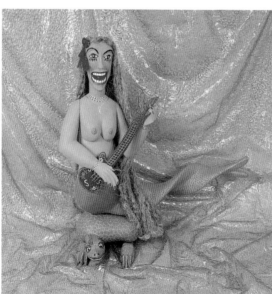

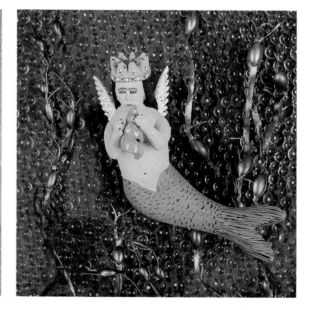

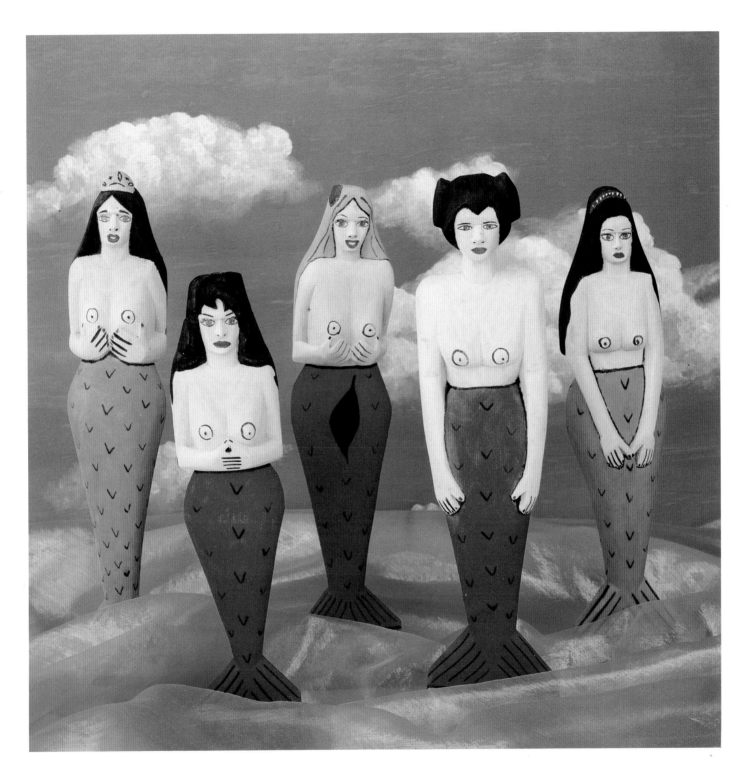

Mermaids

Avelino Pérez

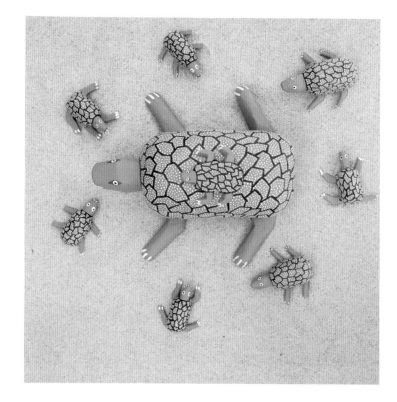

above:

Turtles

Leoncio Martínez

left:

Dog

Rodrigo Cruz

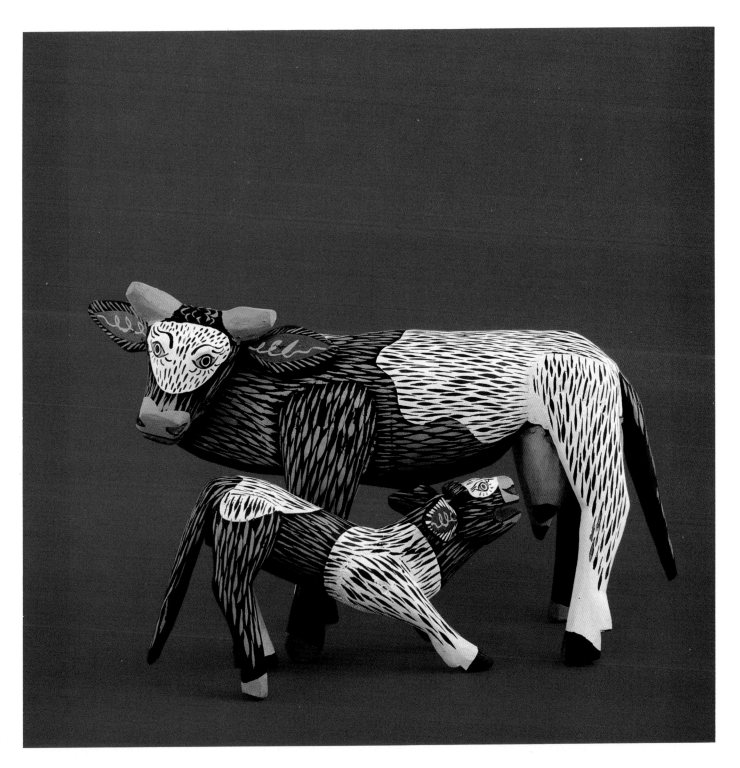

Cow and calf

Xenén Fuentes

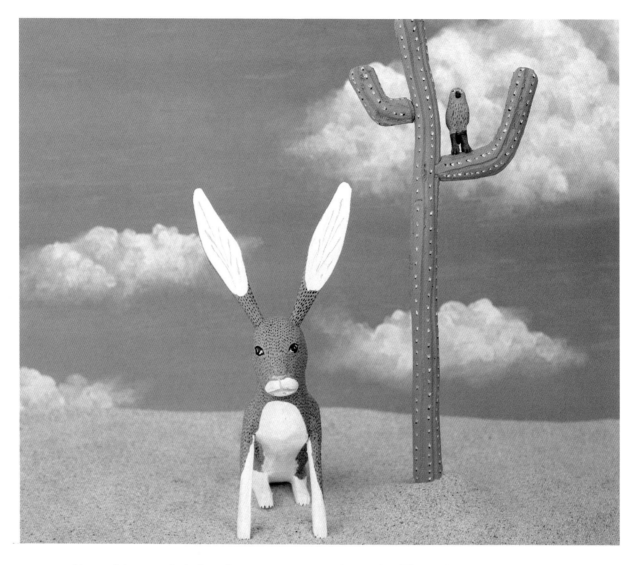

Many of the most lyrical carvings spring from an almost paranoid concern with keeping ahead of the competition and preserving a market niche. This fact seems disillusioning —we would have wished Beauty's muse to be more poetic and mysterious, but it is not.

Inocente Melchor used to make his rabbits thirty centimeters high until he learned that a buyer had taken one of them to a neighbor to be copied. The rival was no match for Inocente, but it didn't matter: the buyer knew that the market wouldn't appreciate the difference, and Inocente had no clear·sense of his own talents. He began making his rabbits smaller. The jackrabbit pictured here is sixteen centimeters high and, as it happens, more lithe and graceful than his larger ones.

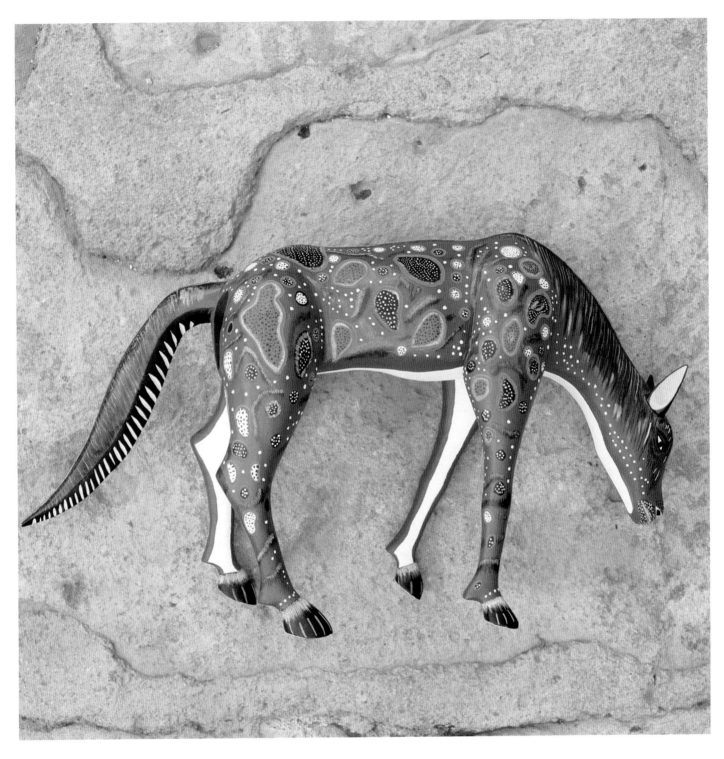

facing page:

Rabbit with cactus

Inocente Melchor

above:

Horse

Gerardo Ramírez

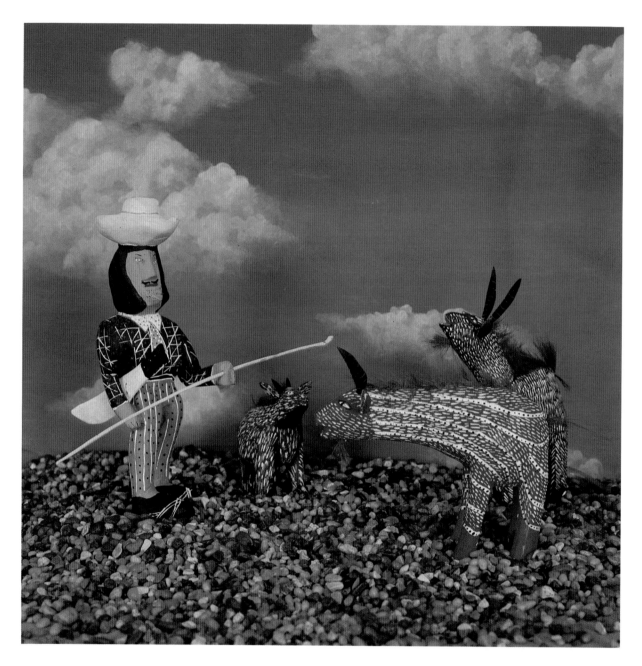

Herder and goats

Ventura Fabián

In recent years, how a piece is painted has become at least as important as how well it is carved. Miguel Santiago, a gifted carver and among the most expensive, goes so far as to take 50 percent off for his unpainted pieces. "They're only half-done," he says.

Most carvers strive for realism in their carving and fantasy in their painting. "Live animals look beautiful because, well, they're *alive*," María Jiménez says. "Wooden animals painted the same way would just look sad. You can't compete with nature, so why bother? Better to use other colors."

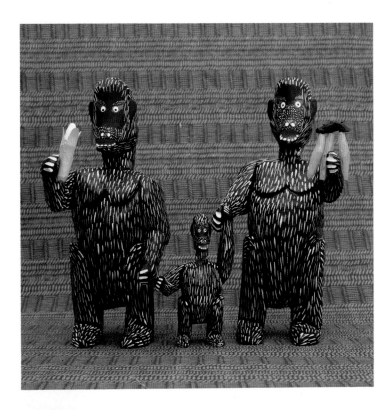

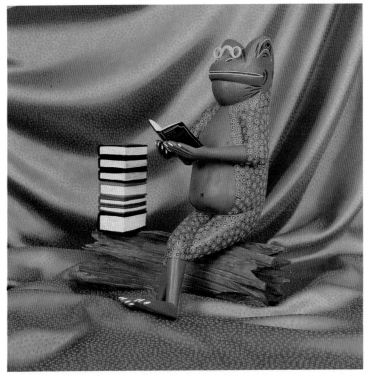

above:

Gorillas

Leoncio Martínez

left:

Reading Frog

Miguel Santiago

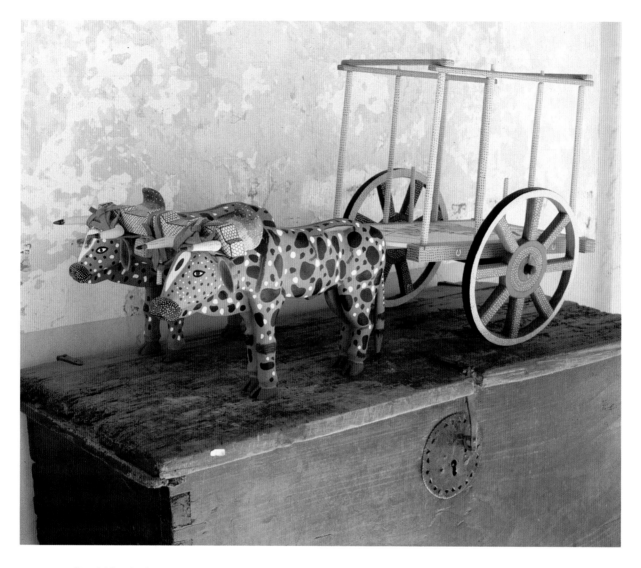

San Isidro is the patron saint of the peasantry. In San Martín, he is also the protector of farm animals. Each year, on San Isidro Day (May 15), residents festoon their bulls, horses, burros, goats, and other animals with flowers and crêpe paper and lead them into the dusty plaza before the village church. There, beneath the great jacaranda tree, they are blessed by the village priest and sprinkled with holy water.

above:

Bull team with cart.

Gerardo Ramírez

facing page:

San Isidro and farmer

ploughing the fields

Epifanio Fuentes

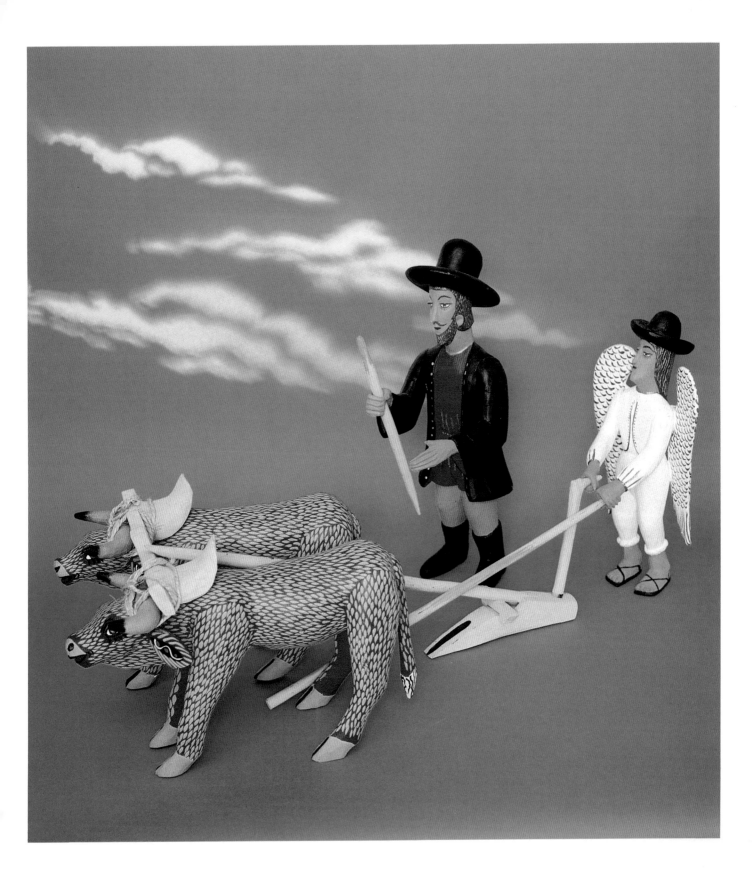

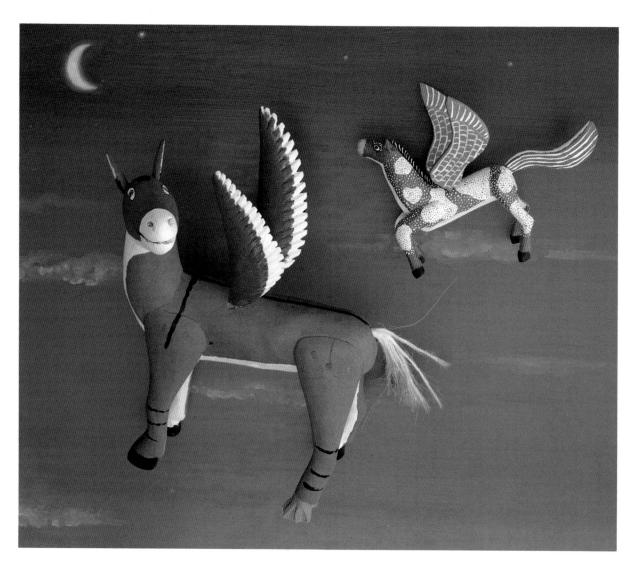

above:

Winged burro

Coindo Melchor

Winged horse

Martín Melchor

facing page:

Old man

Francisco Santiago

Turtle

Martín Santiago

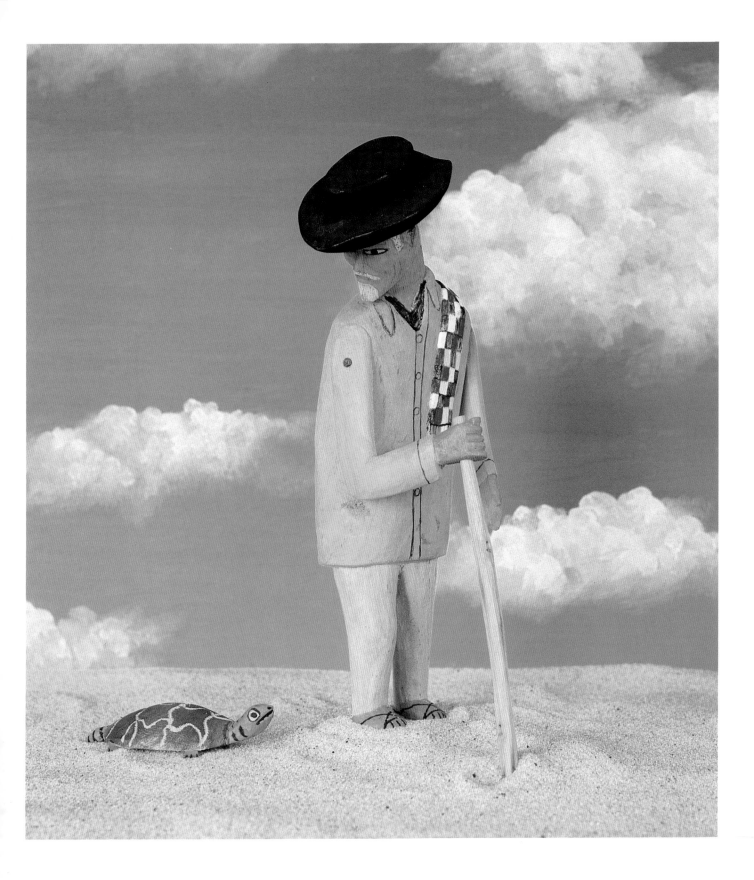

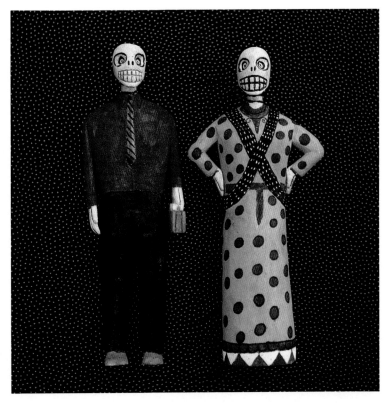

Skeleton couple

Francisco Santiago

DEATH Carver Miguel Ramírez of Arrazola was shot dead in the chest two

years ago by a one-eyed neighbor who took offense to being called Cyclops. Both men were drunk and Miguel was unarmed, but beyond that no one knows exactly how it happened. Ramírez was one of Oaxaca's more promising carvers. Known to all as El Gallo, "the cock," he was in fact soft-spoken and diffident. As a carver, his specialty was carving *retablos* for the Day of the Dead, a festive Halloween celebration in which Mexicans build shrines to their deceased relations, who they believe come back to visit. Miguel's mother now prepares an altar for him every year, setting out his favorite things to eat.

Miguel was killed in the middle of the carving boom—just as buyers were beginning to discover him but before he had made much money for his family. He had just turned twenty-one. The altars he carved were elaborate, multilevel banquets of a Oaxacan's favorite things: tortillas, *mole,* chocolate, mescal, sugary angel bread, oranges, nuts, bananas. The shrines his mother can afford to assemble in his memory are much more modest: a few wild poinsettias, some candles, a portrait of the Virgin Mary.

Life is precarious in the villages, even the prosperous carving villages. Respiratory and intestinal diseases savage the young. Malnutrition is common. Alcoholism is rampant among men, and alcohol-related mishaps strike down men and women, young and old alike. Typhoid, amoebas, parasitic worms,

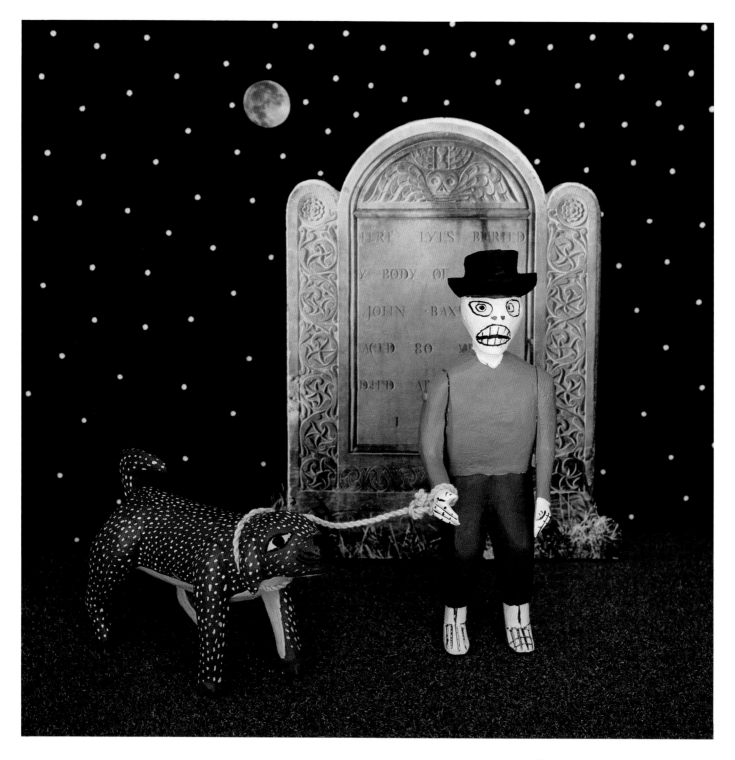

Skeleton walking

a dog

Vicente Garcia

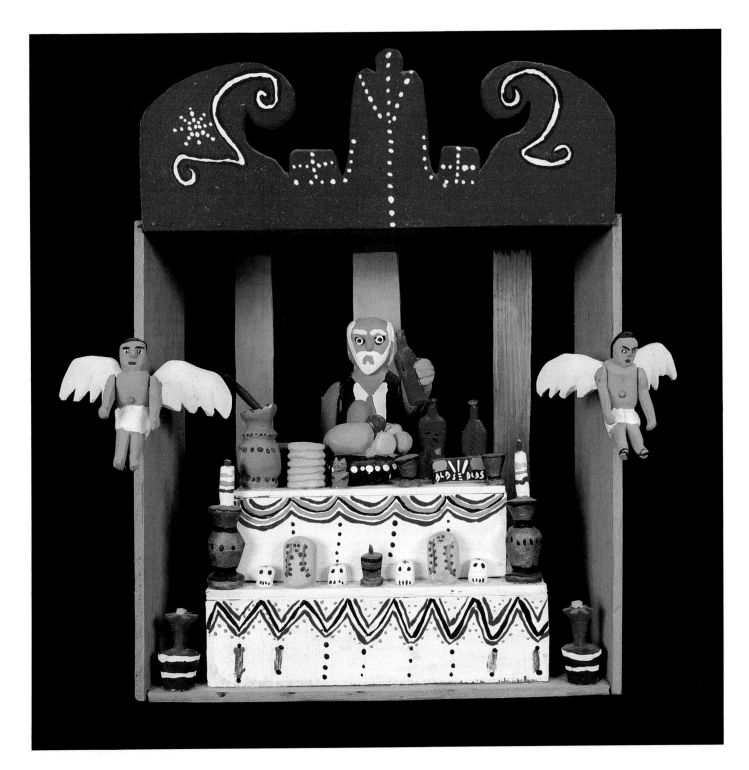

Altar for Day of the

Dead

Miguel Ramírez

hepatitis, and other infectious diseases wash across the populace in great waves, racing from one pit of excrement to another, carried into food and water by the ubiquitous flies, cows, chickens, and dust of country life. Winter colds last for weeks, feeding on bodies run down by dank, unheated rooms, threadbare clothing, and constant labor outdoors. Summer rains bring mosquitoes and dengue fever.

In 1989, twenty-six babies were born in La Unión, and two of them died—a typical year, nurses there say. The numbers, if extrapolated, would yield an infant mortality rate of nearly 77 per 1,000, compared to 43 per 1,000 for the rest of Mexico and 10 per 1,000 in the United States. Until recently, mothers fared no better. According to my own casual survey, one in ten carvers over the age of twenty has lost either a mother or a wife to complications in childbirth. Most died at home, with midwives rubbing pork lard all over them and praying by their sides. Now more women deliver in hospitals, where they are given cesarean sections whether they need them or not.

Dehydration from diarrhea is the leading cause of death in children, and the problem seems at once hopeless and avoidable. One of the babies who died in La Unión was the son of a carver who, like a lot of peasants, does not believe in doctors. He brought to his hut a *chupador,* who attacked the boy's raging diarrhea by sucking out deep purple blood marks across his abdomen. When the child died two days later, the sucker blamed evil spirits, the carver blamed the *chupador,* and the nurses at the local clinic blamed the carver and his wife. They blamed him for not having dug a latrine, they blamed her for refusing to boil the family's drinking water, and they blamed both for not bringing the child to the clinic until he was unconscious. At the wake, the family's neighbors just shook their heads and swapped horror stories about hospitals in the city. "These nurses," one said, "they just don't know anything."

Burial practices in the villages are elaborate. As if to block out the grotesque reality of tiny wasted corpses, parents bury their children dressed as angels. Young unmarried adults are dressed, optimistically, in wedding clothes. Deceased of all ages are sent off with their coffins meticulously packed, as if, like migrants slipping into Texas, they were embarking on some perilous but necessary trip requiring careful preparation and luck. In La Unión, the packing list includes a comb, a mirror, needle and thread,

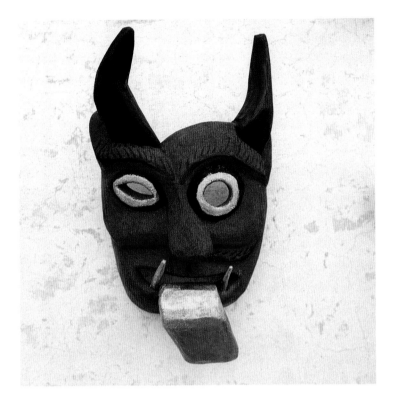

left:

Devil mask

Isidoro Cruz

below:

Death mask

Isadoro Cruz

facing page:
Candlelight celebra-
tion for Day of the
Dead. Graveyard at
Xoxocotlán.

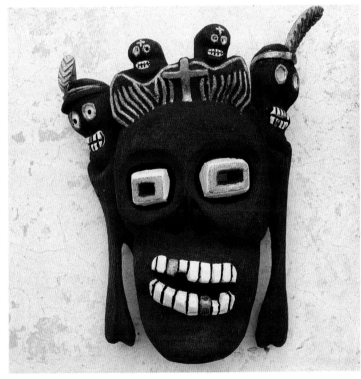

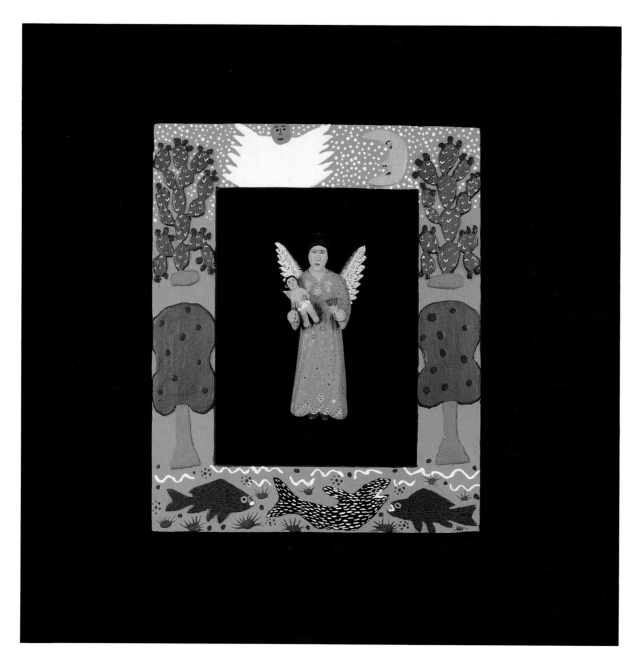

Framed angel

Gabino Reyes

Frame

Roberto Matias

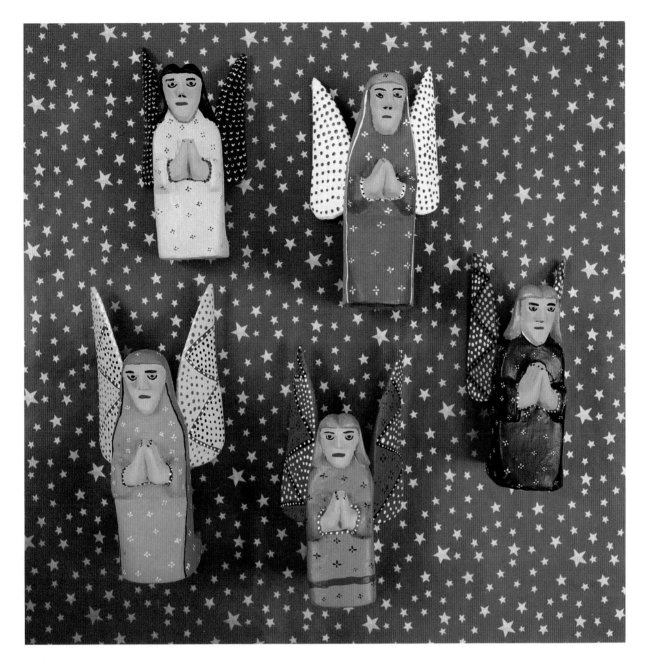

Angels

Inocencio Vásquez

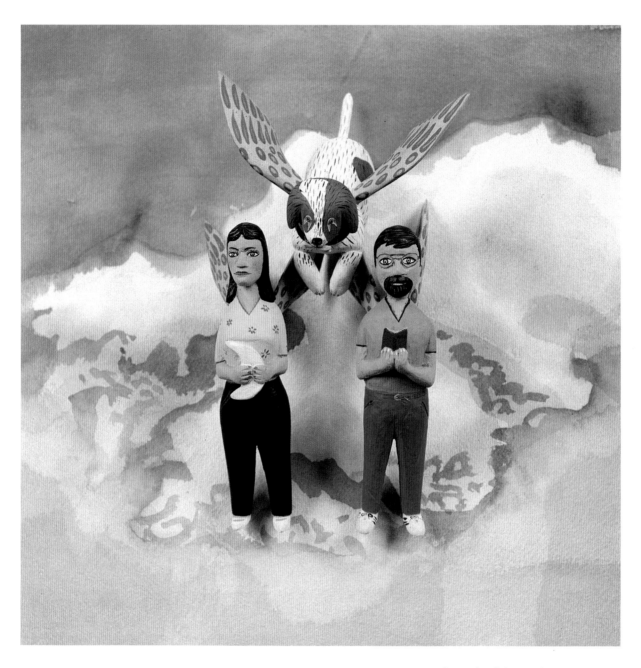

Portrait of the authors

with their dog

Miguel Santiago

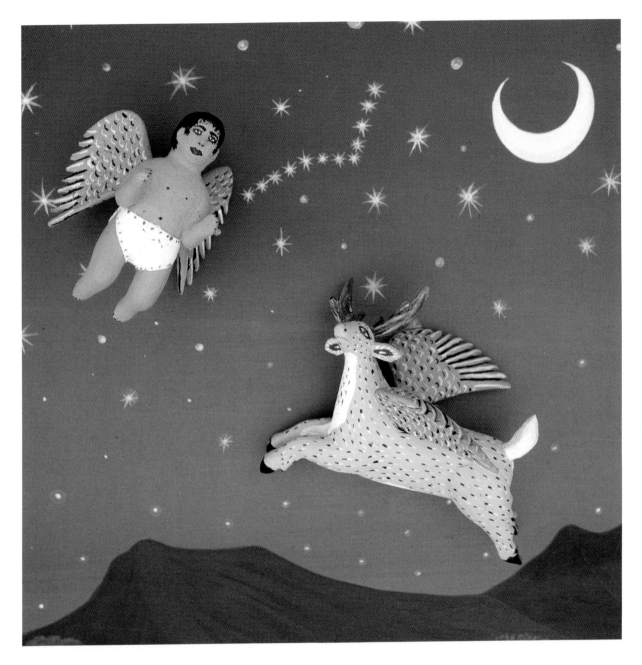

Baby with deer

Gabino Reyes

water, nine cookie-sized tortillas in a napkin, nine pieces of chocolate, an image of a saint or the Virgin, clothes (all of them), sombreros, a stocking hat for the cold, and cardboard huaraches. (Reckless in life, fastidious in death: real leather sandals would be dug up and eaten by the dogs.)

Funerary customs also vary from village to village. Clothing is ceremoniously burned in some, preserved as a memorial in others. The final dinner-to-go depends on what's grown and available. Accessories depend on what a body is believed to meet up with in the next world. The people of Matatlán, for instance, a small village near the ruins of Mitla, bury their dead with a bar of soap. It is completely logical: a soul hoping to enter Paradise must first cross a river. The only way to do so is by boat. There are plenty of boats, all of them skippered by dogs, but some are white dogs and others are black. The black dog is considered good luck in this world because, as a pilot in the next, it invariably agrees to row its otherwise stranded passenger across the river. The white dog, however, always refuses. It says, "I can't, I'll get dirty." Armed for that contingency with the bar of soap, the soul from Matatlán can reply, "But I will clean you on the other side."

Carvers and their families have died in a variety of ways. Plácido Santiago's first wife was put to sleep in a hospital after being bitten by a rabid dog and going mad two weeks later. Margarito Melchor's father-in-law was killed by a truck as he was crossing the highway to chase some goats away from his garbanzo patch. The president-elect of San Martín, Bruno Ojeda, a carver, went out one Sunday in the spring to collect money for the Easter fiesta, drank a half-liter of mescal along the way, returned home, and fell sixty feet headfirst into a dry well, his own. He was a big, friendly man, liked by all, and people now joke that he dug his own tomb. In Arrazola, an eight-day-old girl asleep in her hammock was killed when a dust devil ripped the roof and beams off her family's hut and blew her away into the hills. Manuel Jiménez lost his daughter-in-law and infant granddaughter when his son, Isaias, drunk and hungry, rolled their car off the road leaving Arrazola to buy some tortillas. Isaias now carves with a pin in his arm. Finally there was Miguel Ramírez, shot down by the Cyclops. Except for the rabies, all this happened while we were living in Oaxaca. It was a typical two years.

right:

Horse with angels

Pedro Ramírez

lower right:

Angels

Rodrigo Cruz

lower left:

Angel pair

Antonio Aragón

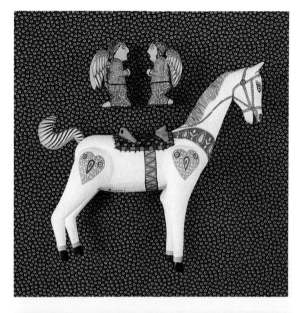

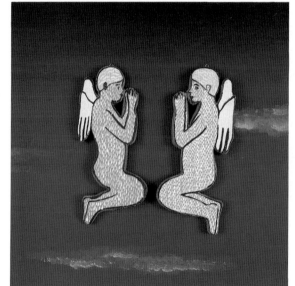

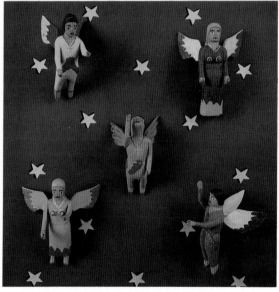

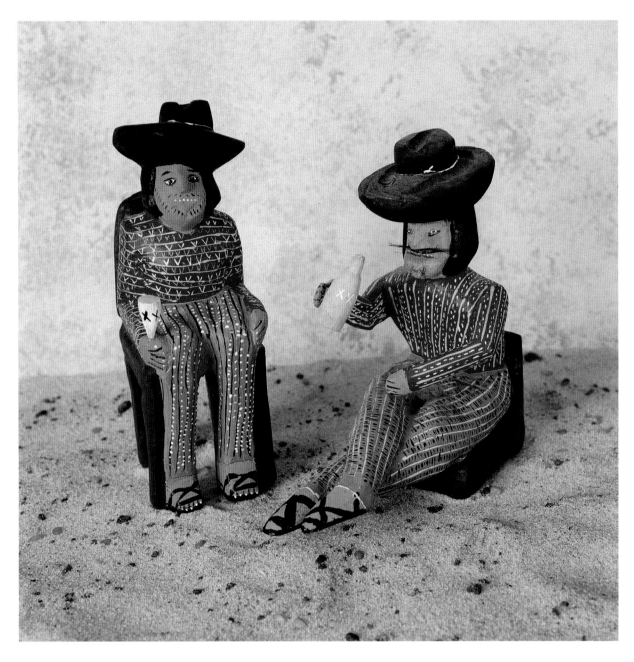

above:

Drunks

Ventura Fabián

facing page:

Skeleton bicyclist

Ventura Fabián

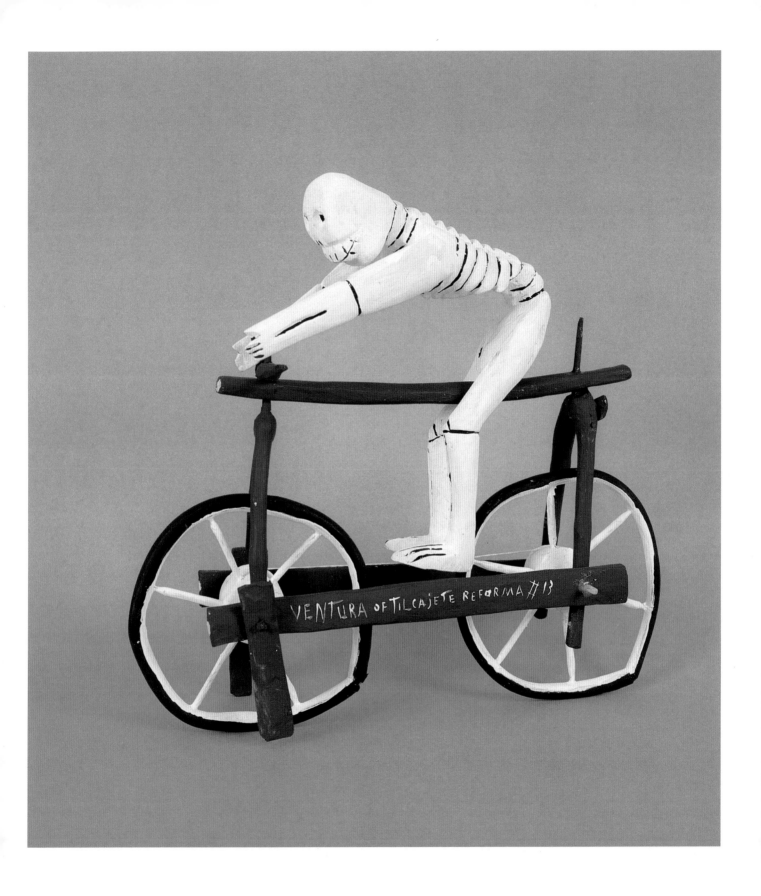

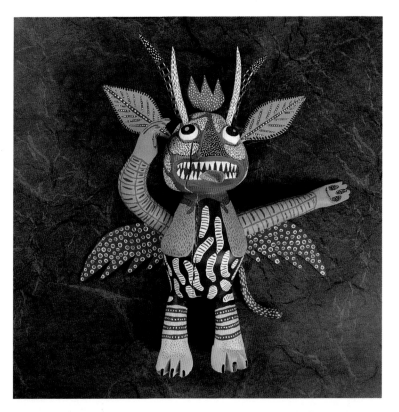

Alebrige after Pedro Linares

Blas family

SUPERSTITION Like the rest of rural Mexico, Oaxaca is a

land rich with superstition. Goats are the devil, owls are good luck, and a sweaty T-shirt can lift the curse of an evil eye. Snakebites cure rabies, mescal stops diarrhea, and skunk meat clears up acne. Witches and other temptresses inhabit the hills outside all three carving villages. There's a rock in San Martín that turns into a woman at noon.

Fanciful carving comes not from mushrooms or mescal but from the carvers' simple willingness to imagine—with extraordinary fecundity—a world less exhausting and dreary and filled with death than their own.

"See these? These are people," Ventura Fabián says, holding up a pair of dancing chickens. "They are *not* chickens, they're Nahuals," ordinary people who can turn themselves into animals at night, especially under a full moon. Ventura, who of all the carvers perhaps best fits the image of the eccentric folk artist, lives in a peculiarly private world where reality mixes with something less immediately verifiable. Sensitive to my status as an unknowing foreigner, he is always watching out for me. "Be careful," he said one day, after his niece next door asked me for a ride into Oaxaca. Lowering his voice, he

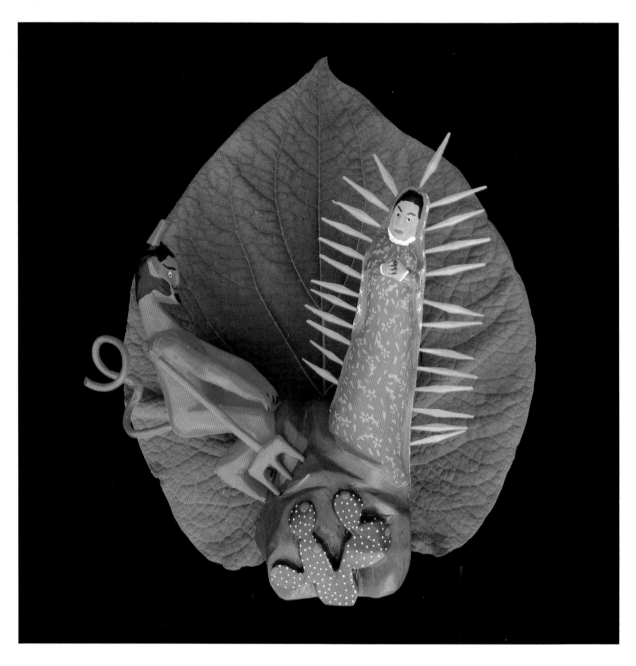

above:

Devil and Virgin

Leoncio Martínez

facing page:

Woman on frog

Isidoro Cruz

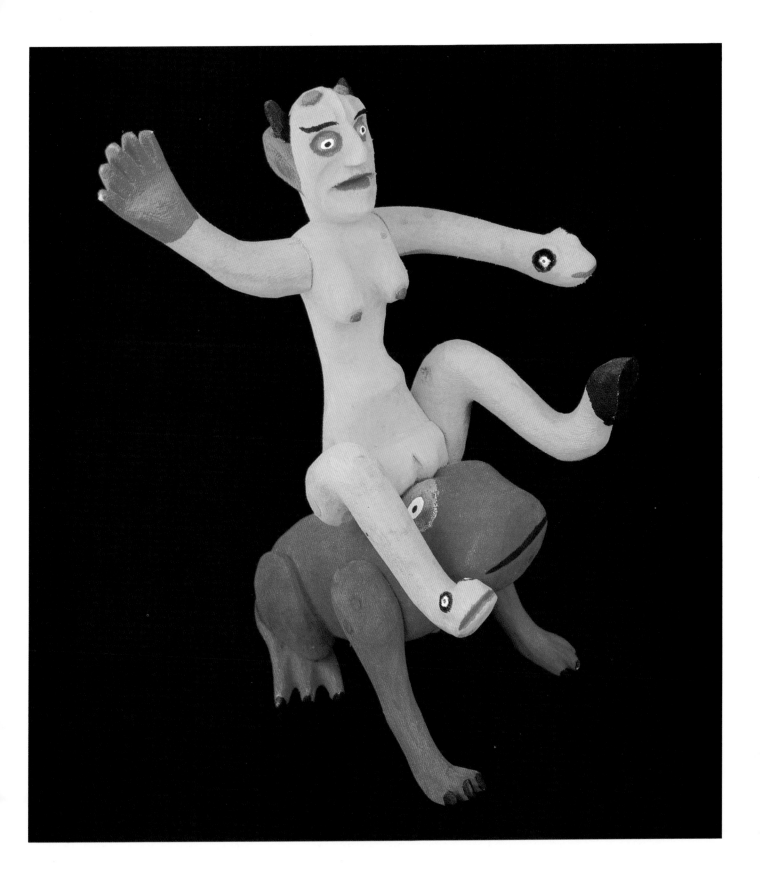

explained, "She's a witch." His carvings are the weirdest, most expressive of all.

Ventura's younger friends think he's strange all right, but even they cannot always bring themselves to act in ways their clients would call modern. They seem torn. In Arrazola, Fidencio Aragón and his wife Marisol did two things when their two-year-old fell ill with diarrhea. First, they took her to a doctor in Oaxaca, who diagnosed a case of amoebas, and they bought a bottle of Flagyl as he prescribed. Then, following a village custom, they went home and prevailed upon the village drunk to take the child to church and pray for her recovery. "A drunk never gets sick," Fidencio explains. "He dies of cirrhosis, but the other diseases don't attack him. So it's believed that maybe his defenses will rub off on the baby. You have to get him when he's hung over, not when he's drunk, or it doesn't work."

Creative beliefs usually confer elaborate duties. Sergio Santos of La Unión took the day off from carving when his daughter was born—not to celebrate, or to bond with the baby, or even to sit attentively by his wife, Adelina, on the dirt floor of the hut where the child was born. Instead, this clear-eyed, level-headed carver, from whom I have heard the most practical thoughts about faith, education, and the business of carving, did what others in his village have done for generations before him. He took the placenta, spread it out on a ceramic *comal,* cooked it like a tortilla for eight hours over an open fire, wrapped it in some old clothes, and tossed it into the river.

Why not just dump it in the fields like the rest of the garbage, or use it for fertilizer?

"Then the child would go blind," says Sergio.

Why not bury it, as some other peoples do?

"Too dangerous. It would attract lightning."

Do you really believe all this?

"I don't take chances." The couple lost their first son four years ago, twenty days after he was born. The cause of death was unclear—no autopsy was performed—and the parents were left wondering what or who was to blame.

The frequent calamities of village life goad the imagination to explain and control events that are too painful otherwise to confront. In 1940, Manuel Jiménez's older brother, Chico, a talented mason, died of alcoholism. No question about it, the villagers say; he drank himself to death. But why? To this day, Manuel, ever creative, says his brother was killed by a group of jealous peers. Nahuals apparently, who cast a spell on him after he'd defeated them in a competition to make a giant watermelon out of cement. "He was the only one who could solve the structural problems of making a lifelike watermelon, and they killed him for it," Manuel recalls bitterly.

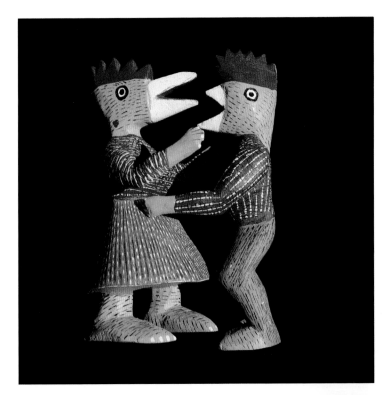

left:

Dancing chickens

Ventura Fabián

below:

Nahuals

Pedro Ramírez

This pair typifies the rapid technical evolution of many carvers. The Nahual on the left was made within a year of the smaller figure.

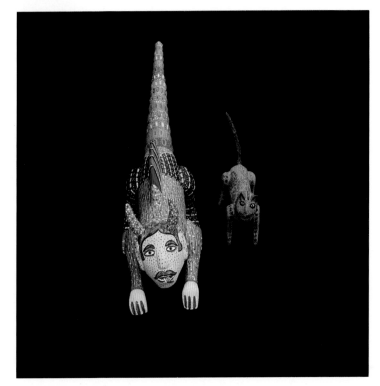

This sort of virtuosic rearrangement of reality shows up again and again in the work of the carvers, for whom drum-thumping, coyote-faced mermaids can be summoned forth from a piece of copal as naturally as a team of oxen. On the other hand, the connection between art-making and mythmaking should not be drawn too tightly. Clients tend to love all the mystery and mumbo jumbo of the peasant worldview, and as a rule they have encouraged the carvers to let their imaginations run.

The carvers have been only too eager to please. Says Alejandrino Fuentes, "A buyer will come and see a tiger playing the trumpet and say, 'Oh, look! That's a Nahual, isn't it?' and we'll say, 'Sure, sure, yes, yes, that's a Nahual. We might not have intended it to be, or we might not have the slightest idea of what they're talking about, but we'll agree. Whatever it takes to make the sale." To lie may be immoral, but to contradict a stranger is bad luck, and, as every peasant knows, bad luck is much worse.

A Sampling of Folk Beliefs and Remedies

Folk beliefs vary endlessly—not only from village to village but from family to family. The following list is based on interviews with carvers and faith healers in the three carving villages. It is by no means definitive.

Problem: Any ailment provoked by the casting of an evil eye.

Cure for infants: Person believed responsible for casting the spell must kiss and/or hug the child, then rub a whole egg all over its body to cleanse it.

Cure for animals: Prepare a mixture of copal incense, crushed corncobs, chicken excrement, chiles, and herbs. Burn so that smoke reaches the animal's face and is inhaled. If that doesn't work, pour dirt over the animal's back.

Problem: Evil eye cast on pot of boiling tamales or fried pork bits, causing both to come out bland and undercooked.

Remedy: Add a whole pestle and one red chile to the pot.

Problem: Woman wants to find a husband.

Remedy: Put an icon of San Antonio upside down while saying prayers or the rosary.

Problem: Woman wants to kill her husband.

Remedy: Same as above.

Problem: Boy wants to stop girl from marrying someone else.
Remedy: Take a piece of her hair or clothing to the cemetery.

Problem: Lost hen or turkey.
Remedy: Ask local seer to help find it. Meanwhile, keep your stone pestle in its mortar to protect the bird from coyotes. Tying a cord around San Antonio's feet also helps.

Problem: Sprayed by skunk.
Remedy: Smoke of copal.

Malady: Acne or other rash.
Cure: Fruit of copal tree. Take six per day, like pills.

Malady: Tuberculosis.
Cure: Skin the tail of a rattlesnake. Boil tail with an onion and salt. Strain. Drink the juice for nine days.

Other beliefs:
Meowing cats and crowing roosters are harbingers of death.
It is bad luck for dogs to fight at a wedding, worse luck for two couples to marry on the same day, and worst of all for a bug to enter the bridal veil.
Odd-numbered calendar years are harder on babies than even-numbered years, and the ninth month in an infant's life is the most dangerous.
Eating an avocado and getting angry at the same time can provoke a hysterical fit, especially in women. Extreme cases produce temporary paralysis.

facing page:

Seated devil

Inocencio Vásquez

above:

Devil tie tack

Roberto Matias

right:

Drinking devils

Inocencio Vásquez

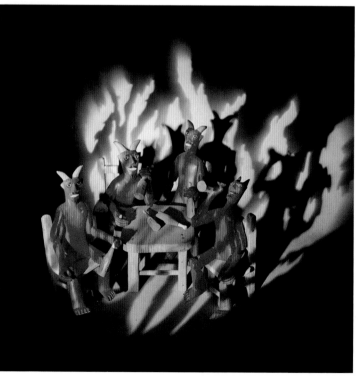

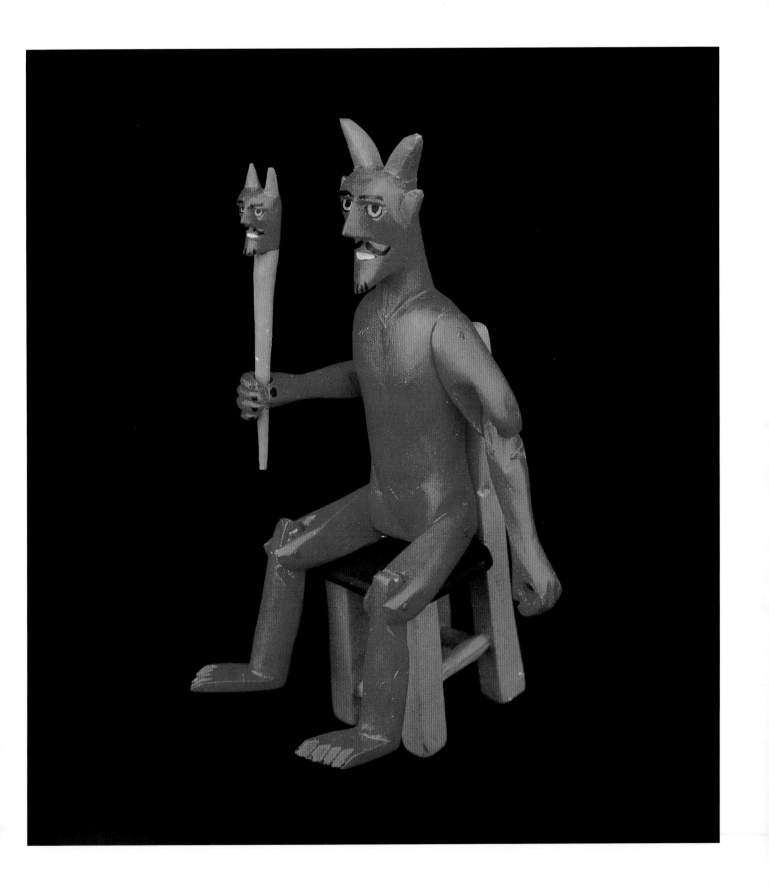

Acknowledgments

A work of non-fiction about the present can be no better than the characters who make it up, and in that regard we have been truly blessed. First, of course, we owe thanks to the people of San Martín Tilcajete, Arrazola and La Unión Tejalapan—the three carving villages whose residents, most of them very private by nature, put up so graciously and for so long with our incessant prying into their affairs. Some of the carvers made it into the book; many more regrettably did not. All deserve our gratitude.

The folk art merchants, an independent-minded, colorful group who lead hectic, bilateral lives, were both generous with their scarce time and free with their information. Thanks especially to Jean Pfankuch Martinez, who has done more for the carvers than anyone alive. Also thanks to Rocky Behr, Octavio Carranza, José Luis Decaro, Enrique de la Lanza, Ralph Farrar, Ramón Fosado, Frank Hale, Robert Hawkins, Clive Kincaid, Claudia LeClair, Davis Mather, Darby McQuade, Mary Jane and Arnulfo Mendoza, Michele and Gabrielle Palatas, and Henry Wangeman.

Many people helped direct our research. Thanks to Henry Glassie at Indiana University; Hendrick Serrie at Eckerd College; Marion Oettinger, director of the San Antonio Museum of Art; folk art collectors Paul and Augusta Petroff; María Teresa Pomar and Ruth Lechuga, both formerly with the Museo de Artes e Industrias Populares in Mexico City; archaeologist Marcus Winter in Oaxaca; Liza Kirwin, a dear friend and folk art specialist at the Smithsonian Institute; Elsa Cameron at the San Francisco Airports Commission Bureau of Exhibitions; Marsha Bol and Barbara Mauldin at the Museum of International Folk Art; filmmaker Judith Bronowski; Tonatiuh Gutiérrez, former head of Fonart in Mexico; Stephen Kowalewski at the University of Georgia; and Arthur Train, the wise man of Oaxacan woodcarving.

Lesley Bruynesteyn at Chronicle Books saw to it that our first experience with publishing was pleasant, honorable, and free of editorial crises. Her sweetness and professionalism were freely bestowed and always appreciated. Friends helped in ways too varied to mention. Thank you Katherine Sweatt for hustling. Thanks also to the former and present U.S. consuls in Oaxaca, Roberta French and Mark Leyes, and to Chinto, the best *taxista* in Mexico.

With sadness we belatedly acknowledge the indispensable help of Cecil Welte, who ran the best library in Oaxaca, and Karen Turtle, who knew the three carving villages as intimately as any foreigner could. Both died before our book went to press but not before they had left their mark on it.

Finally, we thank our parents, Maurice and Lillian Barbash and the late Donald and Doreen Ragan, whose love and support gave us the courage to fly on these adventures so far from home.